MosaicMagic

Simple creative ideas for sophisticated home style

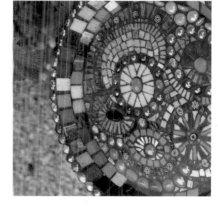

Angie Weston

For, my husband, Pete.
For making all of this possible
and travelling the path with me.

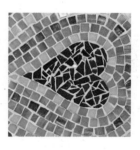

A DAVID & CHARLES BOOK
Copyright © David & Charles Limited 2008

David & Charles is an F+W Publications Inc. company
4700 East Galbraith Road
Cincinnati, OH 45236

First published in the UK in 2008
First published in the US in 2008

A catalogue record for this book is available from the British Library.

ISBN-13: 978-0-7153-2798-2 paperback
ISBN-10: 0-7153-2798-4 paperback

Printed in China by SNP Leefung Pte Ltd
for David & Charles
Brunel House, Newton Abbot, Devon

Commissioning Editor: Jane Trollope
Desk Editor: Demelza Hookway
Art Editor: Sarah Underhill
Assistant Designer: Joanna Ley
Project Editor: Jo Richardson
Production Controller: Beverley Richardson
Photographer: Ginny Chapman

Visit our website at www.davidandcharles.co.uk

David & Charles books are available from all good bookshops; alternatively, you can contact our Orderline
on 0870 9908222 or write to us at FREEPOST EX2 110, D&C Direct, Newton Abbot, TQ12 4ZZ (no stamp
required UK only); US customers call 800-289-0963 and Canadian customers call 800-840-5220.

Rooster bookends

Daisy napkin rings

Poppy candle shelf and saucer

Contents

Beaded glass candle lantern

Hot chilli Tray

Arabian-inspired vase

Introduction

Making mosaics is fun, whether you are a complete beginner or wanting to build on your existing skills. In fact, it's just like completing a jigsaw, except that you select and shape your own pieces before fitting them together. If you want to create a stylish ornamental feature for your home or garden, make an unusual gift for a special friend or spend some quality creative time with your children, this book offers you a range of inspiring projects to choose from. And they can all be achieved with just a few spare hours in the evenings or weekends. Simply begin by following the guide to the materials and tools you need and how to use them that follows, and then try out the basic techniques demonstrated in the subsequent section. You will soon be ready to turn all your mosaic ideas into stunning reality!

MOSAICS THROUGH THE AGES

Mosaic making can be traced back over 4,000 years. Early mosaics were constructed with tapered clay terracotta pegs pushed into rendering on walls, the peg heads coloured and arranged in patterns. Many artefacts from ancient Egyptian and Mexican civilizations were decorated, inlaid or encrusted with mosaic made up of precious stones, such as turquoise.

From around 800 BC, before manufactured tesserae (tiles) were produced, mosaics were made from pebbles, which initially fulfilled only a functional role as pavements and flooring. But by about 400 BC, the Greeks had begun to develop these pebble mosaics into an art form, creating detailed images and disciplined geometric patterns. Around this time, pieces of stone and shell were introduced into mosaic designs. Colours tended to be muted, natural tones such as terracotta, black, white, stone and ochre, with limited blue and green. By 200 BC, specially manufactured tesserae were starting to be produced and glass was also introduced,

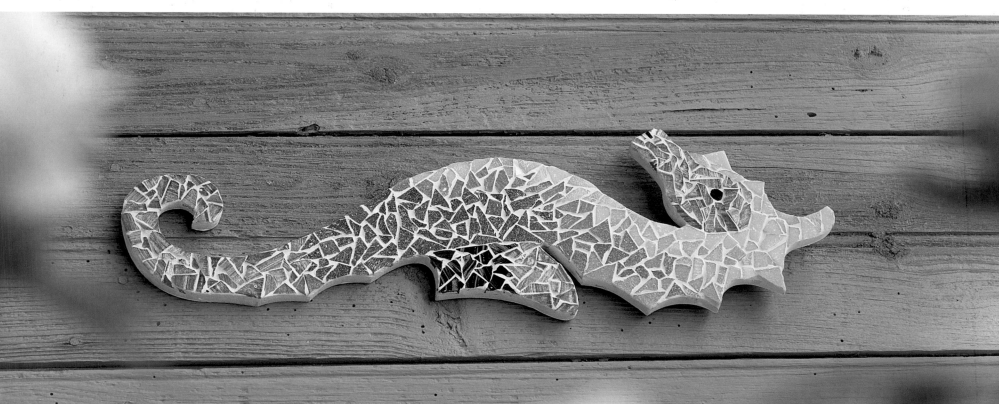

taking mosaic making to a new and exciting level. It was now possible to create a mosaic that was as detailed as a painting.

The Romans carried mosaic making further afield as their empire spread, and some of the finest preserved mosaics are to be found in countries that formed the Roman Empire. The Romans loved the practicality and durability of mosaic floors, using marble and stone in the same way as we use tiles today. Strong geometric patterns and scenes portraying domestic life and celebrating the gods were popular themes.

During the Christian Byzantine Empire of AD 800 onwards, centred on Byzantium (now Istanbul, Turkey), mosaics made a great leap forward in design with the new Eastern influence. In addition, the introduction of smalti tesserae from Italy – cubes of thick coloured glass, often backed with silver and gold (see page 112) – revolutionized mosaic production. A real understanding of colour and light also developed during this period. Consequently, mosaic artists began to see the potential for movement in their artwork, and by angling the smalti into the background mortar, it was discovered that the reflective qualities of the glass and gold leaf could be enhanced. The mosaics created at this time were mostly for ceilings and walls, rather than floors as in the earlier Roman mosaics.

Islamic mosaic art had reached Western Europe by AD 800, bringing complex mathematical, geometric designs and precise structures. During the early Middle Ages, mosaic making went into steep decline until the 11th and 12th centuries, when large mosaics were commissioned by the Christian Church in cities such as Venice and Rome, and in Greece and Sicily.

In the Art Nouveau period from around 1880 to 1920, mosaics were rediscovered and a fresh enthusiasm for the medium began again to grow. Spanish architect Antonio Gaudí (1853–1926) was a pioneer mosaic maker who used found objects, glazed tiles and other waste and broken objects to clad walls and objects with a mosaic 'skin', leading the exploration into three-dimensional sculptural mosaic. The Austrian painter and designer Gustav Klimt (1862–1918) visited the Ravenna mosaics in Italy in 1903, which inspired him to incorporate smalti in his work.

MOSAIC MAKING TODAY

In our modern age, mosaic making is once again growing in popularity and mosaic makers have access to the most amazing range of beautifully manufactured materials and tools, as well as inspirational examples of great mosaic art both past and present (see page 126 for details of some historic mosaic sites). There has never been a more exciting time to start making your own mosaics!

Materials

The following is a guide to the decorative and construction materials used in making the mosaic projects in this book. Additional decorative materials that can be incorporated into a mosaic include pebbles, shells and stones, marble and broken china. Once you gain more experience and confidence in mosaic making, you can expand and develop your resources – mosaic makers are constantly acquiring more decorative materials to feature in their work.

1 Vitreous glass mosaic tiles

These tiles are made by pouring molten glass into moulds. They have bevelled edges, are uniform in shape and size and are manufactured with a rippled underside to aid adhesion. Suitable for interior and exterior applications, the standard tile size is 20 x 20 x 3mm (³/₄ x ³/₄ x ¹/₈in), although some ranges are 15 x 15 x 3mm (⁹/₁₆ x ⁹/₁₆ x ¹/₈in). Generally supplied on either fibreglass mesh or paper (which can be soaked in warm water to remove), they are available in sheets of 225 tiles (15 x 15 tiles) or loose.

Vitreous glass mosaic tiles come in a wide range of colours and finishes. Aside from the standard vitreous glass tiles shown opposite, manufacturers now add metal oxides and mineral salts in the production process, which produces stunning effects, such as metallic and marbleized tiles (see 3 and 4).

2 IRIDESCENT

These have an opalescent, mother-of-pearl finish that produces the effect of movement across the surface, reflecting their changing colours when viewed from different angles.

3 METALLIC

Some metallic-effect tiles have copper veining threaded through the glass, while others have a richer, gold colour – each individual tile varies. Luxurious and alluring, these tiles sparkle and glint in the light.

4 MARBLEIZED

These are swirled with different colours, both complementary and contrasting, giving a fascinating extra dimension to the surface.

5 MINI

Sized 10mm (³/₈in) square, these mini mosaic tiles are the same thickness as standard vitreous glass tiles, making them easy to use alongside them in the same mosaic. They are ideal for children to use or in situations where you want to avoid too much cutting, and are available in a wide range of colours. However, some colours may not be an exact colour match with the standard glass tile of the same designated colour.

6 Ceramic mosaic tiles

Fired clay ceramic tiles tend to be limited to a muted palette of unglazed natural stone and antique colours. The standard size is 20 x 20 x 3mm (³/₄ x ³/₄ x ¹/₈in). Perfect for recreating Roman and Byzantine mosaic effects, these tiles are flat and can be used on either side. They can also be employed very effectively in combination with glass tiles. Although they lack the vibrancy and brilliance of glass, they enhance its reflective quality and vary the surface texture of a mosaic, making it more exciting to the eye.

7 Glass gem beads

These are available in many different colours and finishes including shiny, metallic, iridized and frosted. The transparency varies from completely opaque to completely transparent. They can be flattened or spherical, like a bead of water. All glass gem beads are flat on the back so that they adhere securely to the surface. They can be cut in the same way as glass tiles using tile nippers (see page 12).

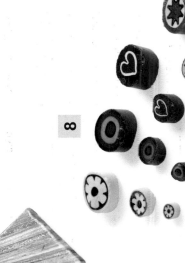

8 MILLEFIORI BEADS

These exquisite glass beads have been made in Italy since the 15th century. Millefiori means 'thousand flowers', the motif being created by arranging thin glass rods into bundles that are then fused together and, while still very hot, stretched. The pattern can only be viewed from the cross-section at the end until they are cut into literally thousands of glass beads. Now available in hundreds of colour combinations, their patterns range from the traditional flower and rosette designs to stars, hearts and swirls.

Opaque millefiori are brighter and perfect for mixed-media mosaics. Transparent millefiori are ideal for glass-on-glass work. Millefiori are generally sold by weight, and diameters and thicknesses will vary.

Mosaic mirror tiles

Mounted onto flexible fabric backing sheets, mirror tiles can be used individually or in sheets. Available in 12–25mm (½–1in) squares, they are also manufactured in circular, triangular and diamond shapes. Small mirror pieces look effective interspersed in watery designs or in mosaics where more reflection is needed. Prolonged exposure to moisture may tarnish the back of the mirror. Many mosaic makers cut mirror pieces from larger household mirror glass.

Materials for mosaic bases

PLYWOOD

Either marine or ordinary, plywood is suitable for all indoor mosaics, as well as for outdoor mosaics if properly sealed (see below).

PRE-CUT MDF BASE SHAPES

These are available in a huge range from craft stores. The shapes are not weatherproof and will need to be thoroughly sealed before using them for outdoor mosaics. Brush the surface all over with a solution of diluted PVA (white) adhesive (one part PVA/white

adhesive to five parts water) and leave to dry. Then apply two coats of yacht varnish to the shape to form a weather-resistant surface. Make sure that you paint the edges thoroughly. Leave to dry thoroughly between coats.

PAPIER MÂCHÉ SHAPES

These shapes, such as vases and boxes, will need to be strengthened before applying the mosaic. Brush all over with a solution of diluted PVA (white) adhesive (one part PVA/white adhesive to five parts water) and leave to dry. Then apply three coats of yacht varnish on top to form a waterproof layer. Leave to dry thoroughly between coats.

Brown craft paper

Used for the indirect or reverse method (see pages 24–25), tiles are glued face down onto the paper with a solution of diluted PVA (white) adhesive.

Mosaic mesh

For large mosaics, tiles can be glued onto mosaic mesh, made from woven fibreglass, then transferred to their final position (see page 26). It is strong, cuts easily with scissors and is flexible. It is suitable for all types of tiles; use with PVA (white) adhesive.

Yacht varnish

Available from DIY stores, yacht varnish is used to seal and strengthen mosaic bases, and provide them with a water-resistant finish. It needs time to cure and should be applied in a well-ventilated area.

PVA (white) adhesive

Inexpensive, child friendly and non-toxic, this is the perfect choice of adhesive for indoor projects and also for gluing tiles onto mosaic mesh (see page 26). It can be used as a sealant if diluted one part PVA (white) adhesive to five parts water. It is water-soluble when wet and water-fast when dry, drying to a clear finish. It is also used to glue tiles to brown craft paper to create mosaics using the indirect or reverse

method (see pages 24–25), diluted in the ratio of one part PVA (white) adhesive to one part water. It is not recommended for outdoor projects, as prolonged exposure to moisture will weaken the strength of the bond.

Polyurethane glue

This glue is transparent, slow drying and non-toxic, with no vertical slippage. Perfect for glass-on-glass mosaics, it dries watertight and flexible, and is suitable for outdoor use.

Silicone glue

This silicone-based adhesive is also great for glass-on-glass mosaics, drying to a transparent and strong finish. It is also ideal for outdoor mosaic work.

Grout

Grout is available ready mixed in tubs or in powdered form. It can be pre-coloured or white and then coloured with paint or pigment (see below and pages 30–32).

Acrylic paint and powdered pigment

Grout can be coloured with either artist's acrylic paint or powdered pigment (see page 32). Water-based paints, such as gouache, or oil-based paints are not suitable for colouring grout.

Grout adhesive

This is available ready mixed in tubs as with ready-mixed grout and is used with the indirect or reverse method to set the tiles in their final position (see pages 24–25).

TIP

Save household screw-top jars, as they make excellent storage containers for tiles. Rows of jars filled with colourful tiles look fabulous on shelves and enable you to see and select from your palette of colours at a glance.

Tools and equipment

You will need a specialist tool for cutting tiles, but otherwise basic stationery equipment for the planning stage and household tools for gluing, painting and cleaning the mosaic are items that you are likely to have already. You will also need woodworking tools and accessories for cutting mosaic bases and hanging or fixing the finished work. Safety equipment is essential for personal protection. As the items detailed here are required for making most of the projects in the book, they are not usually included in the specific 'You will need' lists that accompany each project.

JIGSAW, SCROLL SAW AND WOOD SAW
For cutting wood shapes and boards for mosaic bases (see page 9).

TUNGSTEN CARBIDE-TIPPED TILE NIPPERS
The key tool for every mosaic maker. These toughened steel 'sidebiter' nippers have a carbide-tipped cutting edge for extra strength. Ideal for cutting both ceramic and glass, they are inexpensive and, although slightly less precise than wheeled nippers, a great all-round tool.

WHEELED NIPPERS
These nippers cut exact shapes from glass mosaic tiles with minimal crushing and splintering. Although more expensive than 'sidebiter' nippers, they are the preferred glass tile cutting tool for professional mosaic artists.

TWEEZERS
These are very helpful for moving tiles around in wet glue or placing very small pieces of tile in tight areas, enabling the mosaic maker to manipulate individual tiles without disturbing surrounding areas. A sharp pencil or cocktail stick make excellent alternatives.

MEASURING JUG AND WEIGHING SCALES
It is important to use the correct quantities when mixing powdered grout and water (see page 31). Any equipment used for measuring or mixing grout must be kept solely for this purpose.

TROWELS, SPREADERS AND PALETTE KNIVES
Notched trowels or combed spreaders give adhesive surfaces a good key. Pointed palette knives help to press grout into awkward gaps and embed beads more easily.

GLASS JARS OR PLASTIC CONTAINERS
For mixing grout (see page 31).

DRILL, DRILL BITS, SCREWDRIVER AND SCREWS
For fixings and hangings.

AWL OR GIMLET
For boring into wood to position fixings.

'D'-HOOKS, METAL FIXING PLATES AND CLIPS
These may be required for hanging the completed mosaics.

TRACING AND GRAPH PAPER
For calculating precise patterns or transferring a design from a template.

RULER/TAPE MEASURE
For designing and measuring.

PENCILS, COLOURING PENCILS, WAX CRAYONS AND SKETCHBOOK
For designing, sketching and taking notes. Soft pencils are best – 2B, 4B or 6B.

SCISSORS AND CRAFT KNIFE
For cutting paper, sticky-backed felt or velvet and mosaic mesh.

PAINTBRUSHES
A selection in various sizes is required for varnishing, painting and gluing.

FINE-GRADE SANDPAPER
For smoothing and tidying grout that has set onto the borders of a mosaic. Also used to finish the edges of cut wooden shapes, to remove splinters and smooth rough saw cuts.

SPONGES AND CLOTHS
For cleaning and polishing the finished mosaic work.

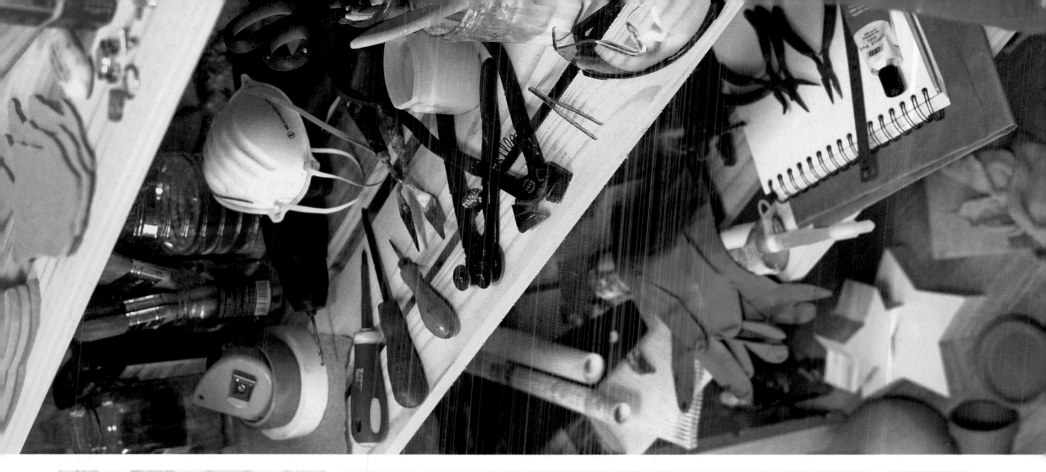

TIP

Recycle plastic drinks bottles for use as grout containers. Cut them in half and you have two disposable pots in which to mix grout.

THE MOSAIC WORKSPACE

Good light conditions and a strong, flat surface at the correct working height are essential, along with access to water. Tile cutting, grouting and cleaning can be messy work, so your workspace should be situated in an area that can be swept and washed down easily. Avoid carpeted rooms unless a suitable protective covering can be applied, and keep cutting and grouting away from areas where food is prepared, or where animals or small children play.

SAFETY EQUIPMENT

Safety goggles are a must for every mosaic maker. Never cut tiles without wearing safety goggles, as flying shards of glass and ceramic can be very sharp. Goggles with extra side protection are best. Dust masks and rubber gloves will protect you from powdered grout dust and wood particles when cutting shapes. Cement is caustic, and both protective items are strongly advised when working with grout. It is recommended that you wear shoes with covered toes, a long sleeved sweater and sturdy leg wear, as pieces of glass or ceramic can sometimes be projected with some force.

Choosing colour

I f you can get to grips with the fundamental rules of colour, then you will be able to give your mosaics a much more professional look. Basic colour theory, formed around the concept of the colour wheel, is simple and will help to bring balance and harmony to your design.

1 Primary colours

Red, blue and yellow are known as the primary colours because they cannot be created from any other colour.

2 Secondary colours

These are the colours that are created when one primary colour is mixed with another primary colour in equal amounts, in the following combinations: red + yellow = orange; red + blue = violet; blue + yellow = green. These secondary colours are also known as complementary colours.

3 Tertiary colours

These colours are created by mixing together one secondary and one primary colour, for example: blue + violet = blue violet. Each tertiary colour is an equal combination of the two colours. The tertiary colours are: yellow-orange, red-orange, red-violet, blue-violet, blue-green and yellow-green.

4 Tones or shades

Tones are created by using one colour but lightening or darkening it to create pale or deep tones of the same colour. Mosaic makers use tone to define light and shade, giving objects depth.

5 Harmonious colours

Colours that sit next to each other on the colour wheel are said to be harmonious. Colours that share the same primary colour will always blend well with each other.

6 Complementary colours

Colours that sit opposite each other on the colour wheel will automatically complement each other. You can find examples of this in nature – for instance, the iris flower with its purple and yellow complementary colours. Bottom are some examples of complementary colour combinations that are striking and beautifully balanced.

6

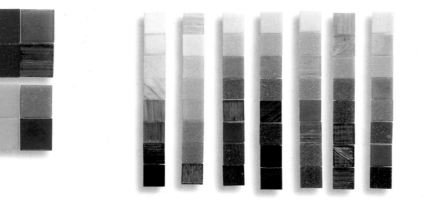

5

3

4

1

2

Design basics

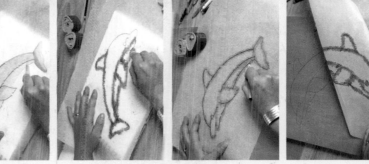

The key to a successful mosaic is in choosing a design that is simple and has a strong line structure or pattern. Although you can use paintings and photographs as inspiration, it is important to remember that the tiles are blocks of colour and when applied will instantly stylize the image.

Start with a drawing, but then try to allow the mosaic to develop through its own momentum by enjoying the accidental, unexpected nuances created by the tile shapes and gaps themselves.

Tracing paper is ideal for transferring designs, although greaseproof (waxed) paper makes a great inexpensive alternative. Graph paper is excellent for constructing precise patterns. Always draw your design to scale, as this will help you decide on the size of your tile.

with wax crayons or colouring pencils for reference, or traced ready for transferring to the mosaic base (see below).

Drawing a design direct

Here, a sunflower motif is sketched directly onto a terracotta saucer and the colour is lightly applied using a wax crayon. Colouring pencils can also be used to apply colour.

Tracing a design

1 In this case, a dolphin motif is sketched to size and coloured in with colouring pencils. The design is then traced from the original sketch onto tracing paper using a thick, soft pencil, such as a 2B, 4B or 6B.

2 The tracing paper is turned over and a layer of pencil graphite applied by scribbling roughly over the back of the image.

3 The image is placed back the right way up on top of a piece of wood. The original lines of the motif are then re-drawn with the pencil.

4 The tracing is removed to reveal the motif on the wood surface.

5 The lines of the motif on the wood are then re-drawn directly to make them dark and clear.

The image is now ready to be cut out with a jigsaw or scroll saw.

TIP
It is a good idea to use pieces of masking tape to help keep the paper in position while tracing.

Using the templates

Templates of all the designs used in the projects are reproduced on pages 118–123. They have been reduced to fit the size of the book page, so need to be enlarged on a photocopier at 250%. Once you have a printed copy at the correct size, it can be coloured in

Designing for 3-D objects

In the case of objects, such as vases or glasses, it can be difficult to conceptualize the design from flat paper into its three-dimensional form, especially if the shape is tapered. Here is an example of how to choose and position a pattern for a glass tealight holder before applying the tiles.

1 Start by wrapping a piece of brown craft paper around the glass.

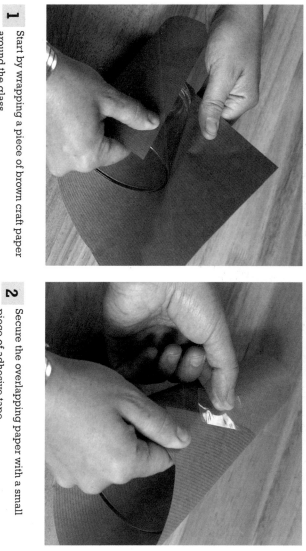

2 Secure the overlapping paper with a small piece of adhesive tape.

3 Trim the excess paper around the top and bottom of the glass – it is wider at the top than the bottom, so cut the paper accordingly. Cut down the side of the glass in a straight line where the paper overlaps. Remove the adhesive tape along with the excess overlapping paper.

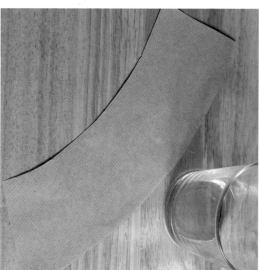

4 When placed flat on a table top, this piece of paper will represent the exact surface area of the glass to be mosaicked.

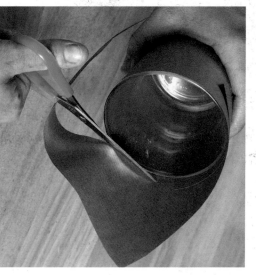

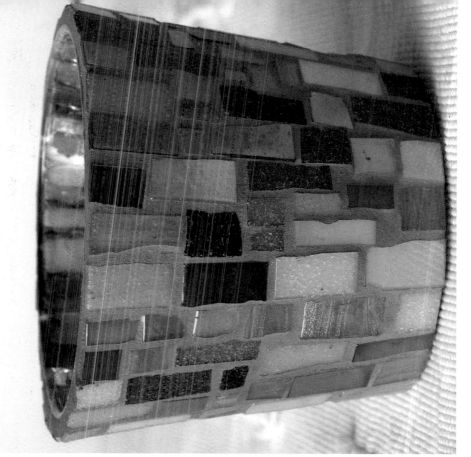

5 You can now cut and shape the tiles, and simply place them on the paper in the desired pattern. You can experiment with moving some pieces and changing the colours, building the pattern as you go.

6 Continue with shaping and positioning the tiles until you have completed your design to your satisfaction and the paper is completely full.

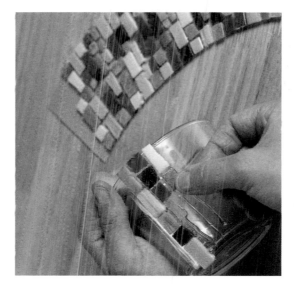

7 You can now begin to transfer the pieces, systematically from left to right, onto the glass using polyurethane glue. Take each piece from the paper individually and re-create the exact pattern on the glass. It should fit exactly.

Tile cutting

Tungsten carbon-tipped tile nippers (see page 12), also known as 'sidebiter' nippers, are suitable for cutting all vitreous glass and ceramic tiles.

It is best to hold the handles of the nippers as near to the ends as possible to allow the spring to make the maximum effort. The tile should be held, viewed side uppermost, firmly between your thumb and forefinger, as shown. Placing the tile between the cutting edges of the nippers and squeezing the handles together will fracture the tile along the desired line. The closer to the edge you nip, the easier it is to break the tile. The action should be gentle and the motion swift and firm, with even pressure. Try not to be tense. The tiles can be placed either side of the nipper cutting edge. Practice cutting the various tile shapes using the different edges of the cutting jaws until you find a position that feels comfortable and cuts the shapes easily.

The more practice and experience you gain, the more accurate your cutting and shaping will become. The key is not to be afraid of the process and to learn to enjoy the interesting shapes that you create.

Square and rectangular shapes

1 Hold the tile square on to the tile nippers, as shown.

2 Squeeze the handles of the tile nippers together in order to cut the tile in half.

3 Divide the tile into quarters in the same way.

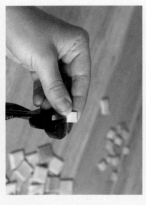

4 The same positioning of the tile in relation to the tile nippers is used to divide the tile into sixths or eighths. These are ideal shapes for creating lines in a mosaic.

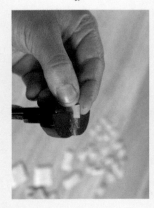

Angled and triangular shapes

Hold the tile in a diamond formation, with the point placed in between the cutting edges of the nippers, as shown here. The point needs to be held firmly between your thumb and forefinger.

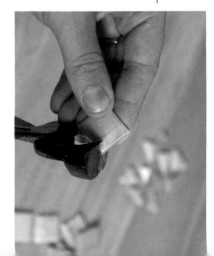

TIP

Although most tiles will fracture in the way you intended, some will inevitably break differently. This should never be a source of frustration to the mosaic artist, as the charm of a mosaic is in the random mix of pieces. Never discard any unintentional-shaped pieces, as you can always find a use for them later, in a different part of the design or other projects.

Ovals and circles

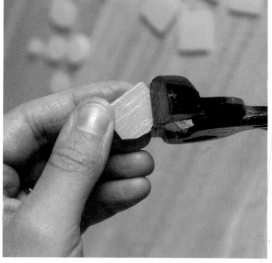

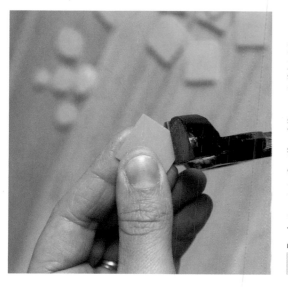

1 Begin to rotate the tile while you 'nibble' the edges with the tile nippers.

2 Continue to move the tile through your fingers as you create a curved edge with the nippers.

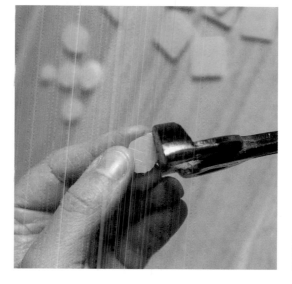

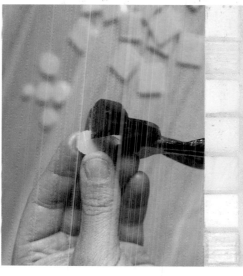

3 Cutting circles requires an even turning and nipping action, and can take quite a lot of practice to perfect.

TIP

If you take too much material off one side, you will have to compensate all the way around and this will lead to a reduced diameter. If you accidentally nip too much, make a straight cut across the bottom and turn it into a neat semicircular shape instead.

Rounded petal or leaf shapes

1 Cut a tile in half. Then round the tile half at one end.

2 Make one straight, angled cut from one end of the curved edge to the straight edge of the tile.

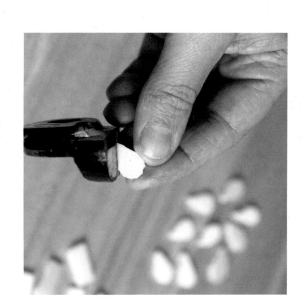

3 Make a second angled cut so that it meets the first angled cut in a point.

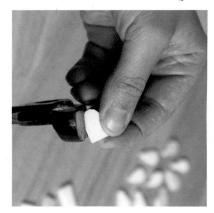

Straight-edged petal or leaf shapes

1 Starting with a rectangular half tile, nip one corner off cleanly by making a triangular cut from the centre of one long edge to the centre of one short edge, as shown.

2 Rotate the tile 45 degrees and make a similar cut on the opposite edge to meet in a point on the short edge.

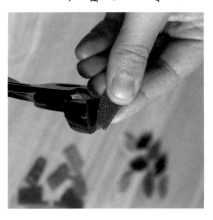
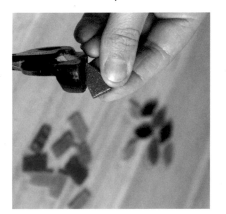

3 Now repeat the cutting action on the remaining two sides to form a diamond shape, to create an alternative stylized, angular petal or leaf shape.

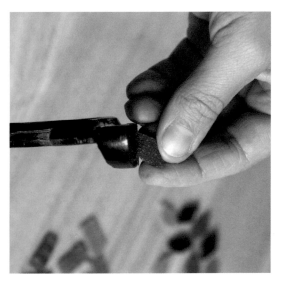

Mosaic effects

The following are examples of the many different ways to lay tiles. The words used to describe these methods are Latin terms that have their origins in Roman art and architecture, and are still used today. *Opus* is the Latin word for 'work' and traditionally refers to the laying down of the tesserae (tiles).

Using different opera will change the 'flow' or look of your mosaic – *andamento* is the Latin term that describes the general flow of the mosaic, that is, the coursing or movement line of the tesserae. Once you understand the various opera, you will be able to pre-determine the ultimate outcome of your mosaic.

Opus regulatum

In the example top right, you can see that the tiles are laid out in a regular grid, both horizontally and vertically. This Roman technique was used to fill in large expanses of background.

Opus tessellatum

In the centre right example, tiles are applied in straight rows, horizontally or vertically. This opus results in a brick wall-type effect. The tiles should not line up across the rows, as this will draw the eye.

Opus palladianum

In the bottom right example, tiles are laid in an irregular, random pattern, sometimes called crazy paving. It is especially important to maintain regular gaps with this opus. Using this opus gives the mosaic maker much more freedom. It is particularly good to mix this opus with a slightly more disciplined one, such as opus regulatum (see above).

Opus vermiculatum

This opus outlines the shape of the mosaic motif to create a halo or aura effect – *vermis* is the Latin word for 'worm'. It emphasizes the design and gives it more energy.

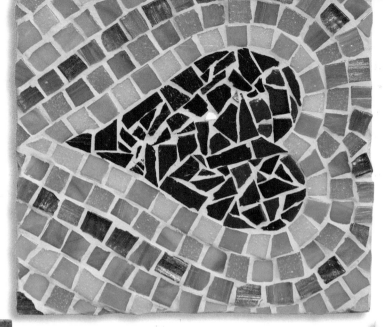

Opus musivum

This opus is created when opus vermiculatum (see above) is extended and repeated so that the entire area is filled. This makes the piece extremely lively and energized.

Opus classicum

This technique combines opus tessellatum (see page 21) with opus vermiculatum (see top), which creates a strong, sharp and clear image.

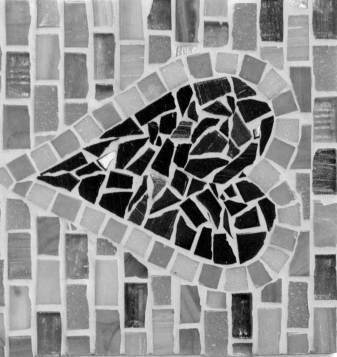

Methods of laying tesserae

There are two different ways to make a mosaic. Both methods achieve the same end result, but vary in the way in which the tiles are applied.

Direct method

This is the most straightforward way of making mosaics. Any of the projects in this book can be created using this method. If you are a beginner, it is certainly the easiest technique to start with, as it enables you to make and view the mosaic while it progresses in its finished form. Each piece of tile is cut and placed face up directly onto the base. Much as an artist will develop a painting, this method allows the creator to build the mosaic in stages, with the option of moving the tiles around if the placement is not quite right straight away. It is the favoured method for three-dimensional objects, such as sculptures and pots. It is not recommended for floors or where the surface must be really smooth.

1 The tiles are applied directly onto the surface by either 'buttering' the back of the tile with glue and pressing onto the surface or applying a layer of glue to the surface, working over a small area at a time, and pressing the tiles down onto the glued area.

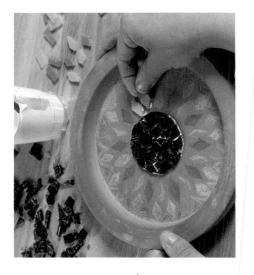

2 When the tiling is complete, the mosaic is left to allow the glue to dry completely.

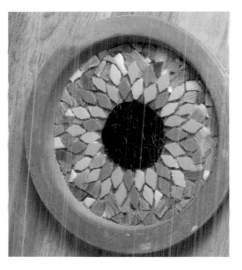

3 The mosaic is then grouted and polished to finish (see pages 28–35 for grouting and finishing techniques).

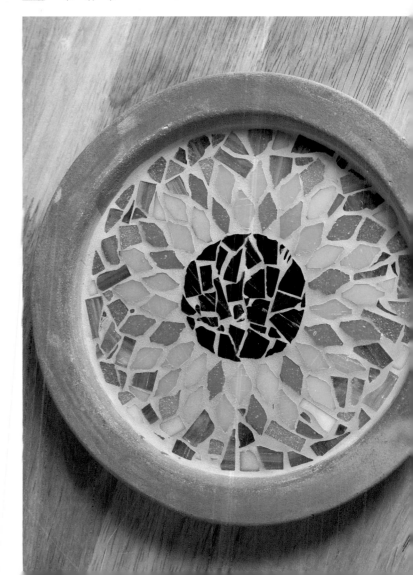

Indirect or reverse method

This method involves completing the design in reverse by gluing the tiles upside down onto paper. When the mosaic is ready, it is flipped over onto a bed of grout adhesive. Once the adhesive has set, the paper is removed to reveal the finished mosaic the right way round.

It is fairly easy to use this method with glass and unglazed ceramic tiles, as they are the same colour front and back. However, the technique can be more challenging with glazed ceramic tiles that do not have the same glaze colour on the underside.

The indirect method is used for larger projects where the direct method is unsuitable; the mosaic can be broken up into sections and applied where access may be difficult. Many mosaic commissions are created in this way in studios, then transported to the final site for installation. It is ideal when using tiles of different thicknesses and a flat surface is required – table mosaics are often made using this method.

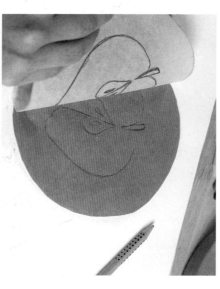

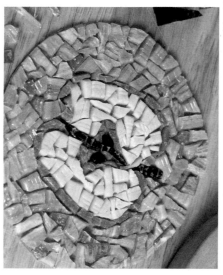

1 A soft pencil (see page 12) is used to trace the design onto tracing paper. The traced image is then placed face down onto brown craft paper and the lines of the image re-drawn to transfer it in reverse to the brown paper.

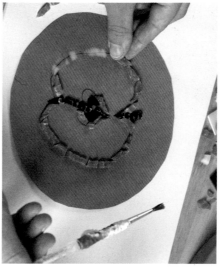

2 A solution of diluted PVA (white) adhesive (one part PVA/white adhesive to one part water) is used to adhere the tiles to the paper, which are applied upside down. If using glass tiles, the smooth side must be placed face down.

3 Once the paper has been completely tiled, it is left until thoroughly dry.

4 To transfer the mosaic, a layer of grout adhesive (see page 11) – coloured in this case – is spread onto the chosen surface, then a hatched pattern scored to give the adhesive surface a key.

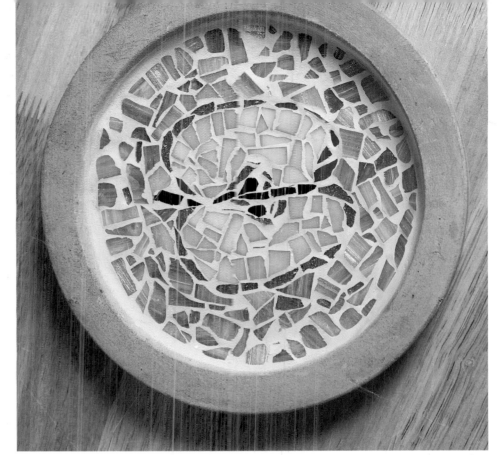

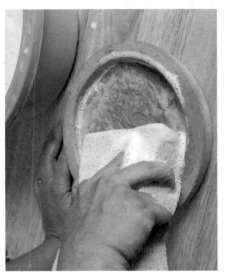

5 The paper is turned over and the tiles pressed firmly and evenly to embed them in the adhesive. The adhesive is then left to dry.

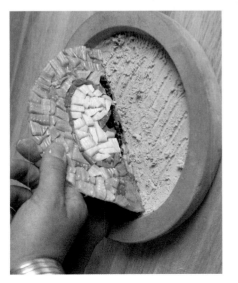

6 A moderately wet sponge is applied to the paper, allowing the water to soak through and dissolve the glue – warm water will dissolve the glue more quickly than cold water.

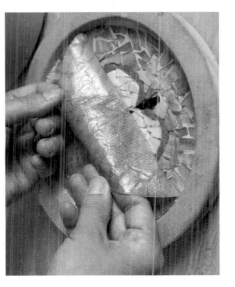

7 Starting at the edge, the paper is peeled from the tiles. It should lift off smoothly and evenly, but if the paper begins to tear or is difficult to remove, soak for slightly longer and try again.

8 Once the paper has been removed, the mosaic will be the right way up and is ready for grouting and finishing (see pages 28–35).

Mosaics on mesh

For larger mosaic projects, such as bathroom splash-backs, mosaic mesh (see page 11) can be used to enable the mosaic maker to create the mosaic the right way round, using the direct method (see page 23), on a flat work surface, and then later transfer it to the upright position on the wall.

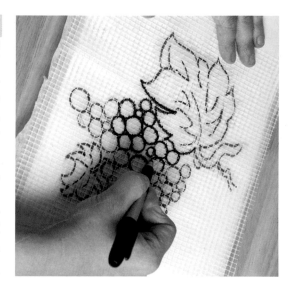

1 To transfer the design onto the mesh, it is placed under the mesh so that the design can be seen through the net. A marker pen is then used to draw over the lines of the design onto the mesh.

2 The tiles are applied to the mesh directly using PVA (white) adhesive. Once the mosaic is completed, the mesh is cut close to the edge of the design and the glue left to dry thoroughly.

TIP

It is a good idea to place a piece of non-stick paper underneath the mesh to stop the glue sticking to your work surface through the net.

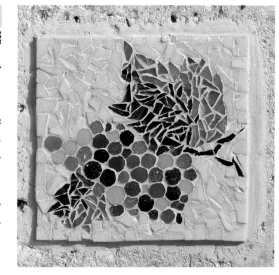

3 The mosaic is now ready for moving to the chosen surface. Here, the wall has been spread with grout adhesive (see page 11) and the net is pressed into it evenly to embed the tiles.

4 When the grout adhesive has completely set (it should be left overnight or for 24 hours), the mosaic is then grouted and finished in the usual way (see pages 28–35).

Further mosaic effects

Most mosaic artworks are flat, two-dimensional images with the effects of movement achieved through using the various opus applications and choosing an appropriate style to best suit the 'flow' of the design (see pages 21–22). But there are some other ways of adding extra dimensions to your mosaic, such as introducing raised layers or several different grout colours into a piece.

The mirror on the right with a tropical fish theme has been made in the traditional form, keeping the design within the frame borders and using a single grout colour.

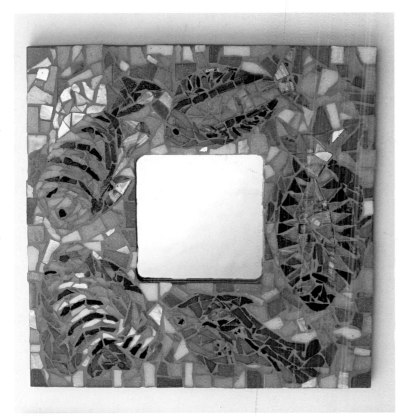

Compare this to the mosaic on the left, which is the same design, but in this mirror, the fish have been made more prominent by changing their grout colour (see pages 28–29). Placing them so that they break out of the frame has emphasized their movement through the water, giving the mosaic extra animation. To achieve this effect, the fish mosaics are made separately and completed before being mounted onto the frame, which is then tiled and grouted around the fish. The difference in depth and clarity is clearly demonstrated.

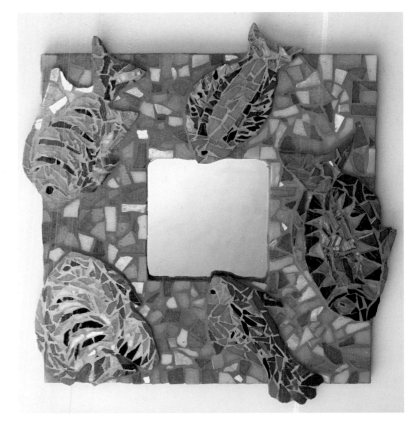

Grouting

Grout is used for practical purposes – it protects the mosaic from damage caused by dirt, weather or general wear and tear, and stabilizes the mosaic by bonding the tiles together, giving it structural integrity. Grout makes the surface smooth and unbroken, which is especially important where many sharp pieces have been used and consequently need to be made safe to touch.

Choosing the grout colour

It is difficult to express just how important the grout colour is to a mosaic. You should ideally choose both your design and grout colour simultaneously, as both are equally important in mosaic making. Laying the tiles is only the first half of the production process and the grout plays a critical role in the overall look of the finished mosaic. Therefore, great consideration should be given to its choice.

The following examples are designed to show you the powerful effects that changing the grout colour can have on the finished mosaic. Each of these six mosaic squares is made up of the same 16-tile formation. The glass tiles used here effectively soak up some of the colour from the surrounding grout colour and therefore some of that colour is incorporated into their appearance.

The mosaic maker is essentially looking for a harmonious balance of tiles in relation to the gaps between them.

1 This white grout is very stark and harsh. It draws the eye and highlights the gaps rather than the colours. White grout is very popular in Mediterranean mosaics, but generally it is best avoided, as it overpowers the image.

2 Cream grout can also drain colour from the tiles and emphasizes the gaps.

3 Mosaics grouted with black grout are reminiscent of a stained glass window, and stained glass templates are often popular sources for the mosaic artist. Here you can see how similar the effect of outlining the tiles in black grout can be to stained glass.

4 Dark grey is a very effective grout colour for mosaics, although it will sometimes 'drown' lighter or pale-coloured tiles. Grey has a wonderful way of unifying and solidifying mosaics.

5
6 As you can see from these two examples, different looks can be achieved by picking out one or two of the tile colours and mixing the grout tone to match. In the green example (5), the tile colours have been muted, while in the blue example (6), they have been enhanced. This is a great way to colour-match a mosaic to your room décor – simply choose a grout colour to coordinate your mosaic with a specific fabric or paint.

TIP
The secret to a well-chosen grout is that, while it may constitute up to one-third of the surface area, it should never detract from the tiling and should not be immediately noticeable on first viewing the mosaic. After hours of careful tiling, you don't want people homing in on all the gaps in your design rather than the actual tiles!

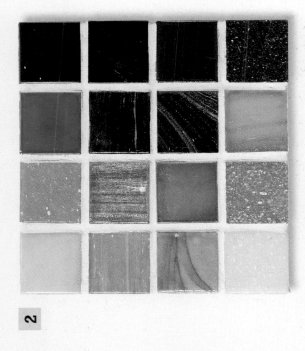

2

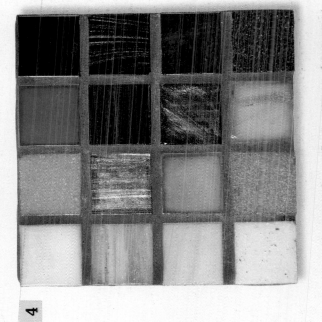

1

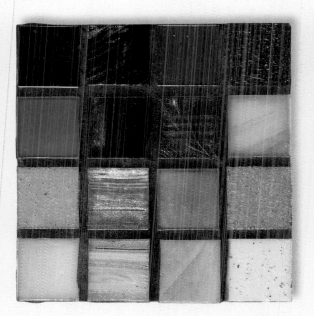

4

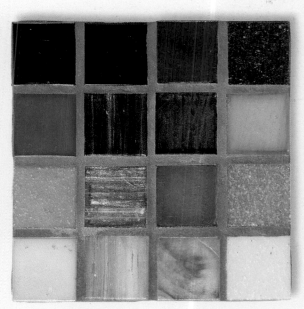

3

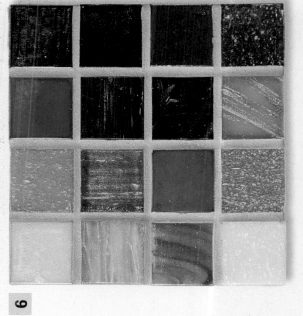

6

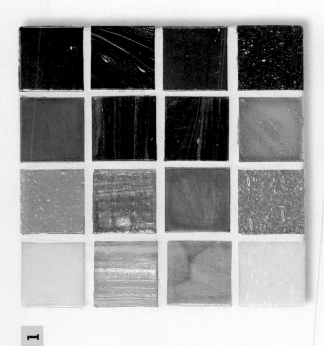

5

Types of grout

There are two main types of household grout available for mosaic making: ready mixed and powdered. Advanced mosaic makers can also use cement grouts (see pages 112–113).

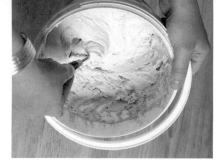

Ready-mixed household grout

(see page 32).

Available in all hardware stores, the great advantage of these tubs of ready-mixed grout is that they will remain usable for several weeks after opening (providing the container is resealed) and do not require any mixing or preparation. They are particularly suitable for the first-time mosaic maker who may not easily be able to gauge the consistency required. Ready-mixed grout sets quite slowly – it takes about 24 hours to harden fully – which is another great advantage for beginners, allowing a more leisurely pace of working.

This type of grout is unsuitable for outdoor mosaics, as it is not designed to be weatherproof, but is perfectly good for indoor mosaics. Household grout is not as flexible or moisture- and mould-resistant as most powdered grouts, although the majority are designed for use in high-humidity rooms, such as bathrooms and kitchens, and have some resistance to moisture and mould. Don't worry if white is the only type available, as you can use paint or pigment to colour it (see page 32).

Powdered grout

Also available in hardware stores and through mosaic suppliers (see page 124), powdered grout is usually cement and sand based, and needs to be mixed with water to create a workable paste. It is ideal for all outdoor and indoor mosaic work, fast setting and drying, manufactured to be waterproof, frost-proof

and flexible, and also contains anti-mould technology. Powdered grout is available in more than 26 different colours, including white, and with the addition of pigment, further tones and hues can be achieved (see page 32).

Although these powdered grouts can be stored for up to 12 months unopened before use, they will usually set within 30 minutes once mixed. In fact, with this type of grout, time is the limiting factor, as it can be fully hardened in as little as an hour. For this reason, you should only mix a small amount of grout and work on just a small section of your mosaic at a time. Don't wait longer than 15–20 minutes before you start the finishing process. Most powdered grout is suitable for filling joints (gaps between mosaic pieces) 2–12mm ($^3/_{32}$ in–$^1/_2$ in) wide.

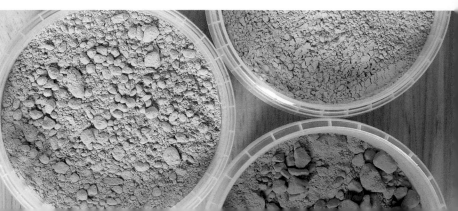

TIP
You should always wear rubber gloves when using powdered grout, as cement is caustic

Preparing powdered grout

When mixing up powdered grout, to avoid too much inhalation of powder, it is recommended that you work in a well-ventilated area and wear a dust mask. You will also need to wear protective rubber gloves.

YOU WILL NEED rubber gloves ■ dust mask ■ old newspaper or scrap paper ■ packet or tub of powdered grout ■ water ■ measuring jug and weighing scales ■ glass jar or plastic container ■ small trowel or pointed palette knife

TIP
Avoid whisking or beating the grout mixture, as this will trap too much air. You must then use the mix within 20–25 minutes.

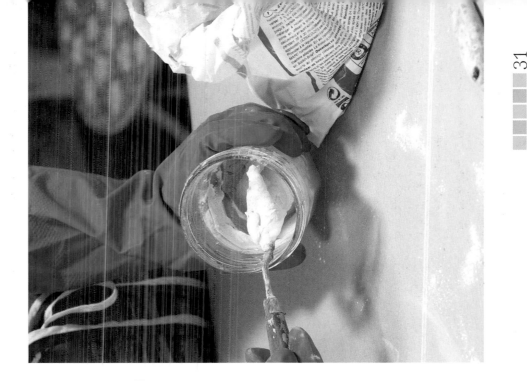

1 Protect your work surface with old newspaper or scrap paper if necessary. Before opening the packet or tub of grout, read the instructions carefully, as these specify the required ratio of powder to water. As a general rule, 100g (3½oz) powdered grout will need 20–25ml (0.6–1fl oz) water. Weigh out the required ratio of powdered grout. Measure the recommended amount of water into a measuring jug.

2 Put the powdered grout into a glass jar or plastic container. Begin to add the water to the powder, a little at a time, stirring continuously and slowly with a small trowel or palette knife.

3 Continue to stir until all the powder has been absorbed and you have a smooth paste.

4 Let the mix stand for 2–3 minutes and stir again briefly before use.

Pigment versus paint

While it is advisable to use pigment to colour grout for outdoor mosaics so that the full strength of the structure is maintained, it is also possible to use acrylic paint to colour grout, and this can be employed very effectively for indoor or smaller mosaic projects.

Paint

Acrylic paint is available in hundreds of colours through art suppliers and hardware stores. It is usually much cheaper than pigment and is easy to mix several colours together to get the exact shade or tone you want.

When using acrylic paint to colour powdered grout, it should be added to the powder, and the amount of water that you would normally add to the powder should be reduced to take into account the addition of the paint and its moisture content. If the mix is very watery, through the addition of too much paint or water (the latter also applies to grout coloured with pigment, see right), cracks may appear as the grout dries out.

Using acrylic paint to colour ready-mixed grout will change the consistency of the grout and therefore affect the drying time.

Pigment

Pigment is finely ground powder made from pure minerals, metal oxides or salts. This will give an intense, deep colouring to the grout. As a general rule, 10% is the maximum ratio of pigment to grout allowable in order to maintain the full strength of the grout structure.

The pigment powder is simply mixed into powdered grout before the water is added or alternatively added directly to a tub of ready-mixed grout. Widely available through all mosaic suppliers (see page 124), pigment is the most effective way of achieving long-lasting colour.

You will not be able to change the colour of already dark-coloured grout very effectively and the amount of pigment required to do so will be problematic. Wherever possible, pigment or paint should only be added to white or pale-coloured grout.

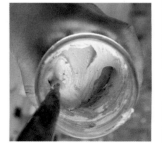

TIP

When colouring grout yourself, always mix more than you need, as it will be difficult to mix two batches exactly the same if you find that you haven't mixed quite enough.

How to grout mosaics

Grouting is not a difficult technique, but it does require a degree of confidence. Mosaic artists are divided into two categories: those who love grouting and those who loathe it. It can be alarming for the first-time mosaic maker to see their hours of hard work laying the tiles disappearing under a bed of sludgy grout, and there is often a reluctance to grout at all. But once your mosaic begins to emerge from beneath the grout, any reservations you may have had will quickly disappear as the excitement of revealing your completed mosaic takes over. There is no more satisfying a feeling than seeing your mosaic finally appear in its finished form.

Mosaic grouting is slightly different from normal household grouting, as you actually want the grout to be flush with the surface tile. With standard bathroom tiling, the grout joint is generally slightly recessed, resulting in a shallow dip between the tiles. Bathroom tiles are usually manufactured with rounded, safe edges, but with mosaic pieces that are often sharp and pointed, the grout is used to smooth the surface and make it safe to touch and therefore needs to be level with the tile surface.

Grout drying time is affected by air temperature and humidity. It is best to grout when the temperature is 5–30°C (41–86°F). If it is a very hot, dry or windy day, it may be necessary to dampen the joints a little after cleaning but before final hardening to improve the finish.

Grouting should always be carried out in a well-ventilated area and it is advisable to protect your work surface with paper before you begin. Protective rubber gloves and an apron are recommended.

Your mosaic adhesive must be completely dry, and the gaps between the tile pieces clean and free from dust and particles. To apply the grout, you will need a pointed palette knife or plastic spreader to 'butter' your mosaic.

1 Load a pointed palette knife or plastic spreader, or the mosaic surface, with the grout and then apply pressure to squeeze the grout down into the gaps between the tiles by drawing the knife or spreader carefully across the surface of the mosaic.

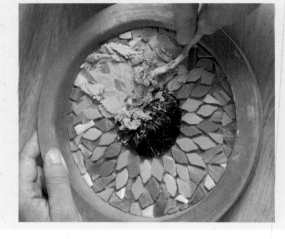

2 Spread the grout over the entire surface until you are satisfied that all the gaps are filled.

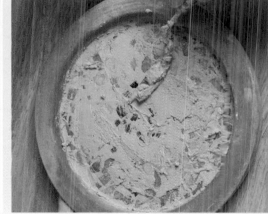

3 Clean off the palette knife or spreader and use to scrape any excess grout carefully from the surface, wiping it back into the pot as you go. Take care not to remove any grout from the gaps; keep the knife or spreader level and the action smooth. Leave to set until just firm to the touch (usually after about 20 minutes); if it moves when pressed, it isn't ready.

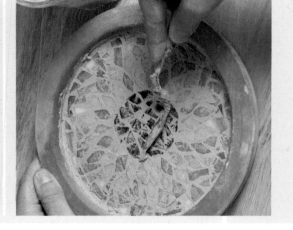

4 Using a moist sponge or soft cloth, begin to remove the excess grout from the surface by wiping with a gentle, even motion. Take care not to gouge grout out from between the tiles. If the grout begins to wash from the gaps, wait for it to set a little harder. Work the surface methodically and check the grout consistency at all times. Wash the sponge or cloth regularly in clean water so that you are cleaning the surface and not continuing to spread the excess grout. The cloth should be just moist; if too wet, you will literally wash the grout out from the gaps.

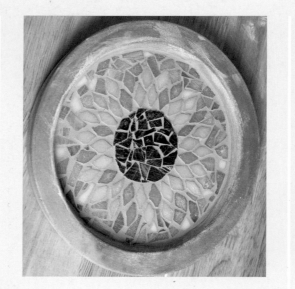

5 Once you have removed all of the excess grout, your mosaic will be left with a dusty film or 'haze' of residue over the surface. You must now leave your mosaic to dry completely – this can take up to 24 hours.

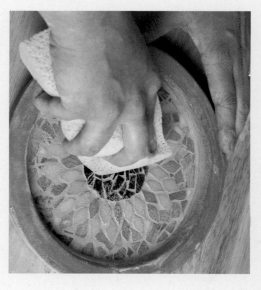

6 Once the mosaic is completely dry, remove the layer of residue by buffing up with a clean, dry soft cloth. A little household polish added to the cloth will help to give the glass tiles an extra shine.

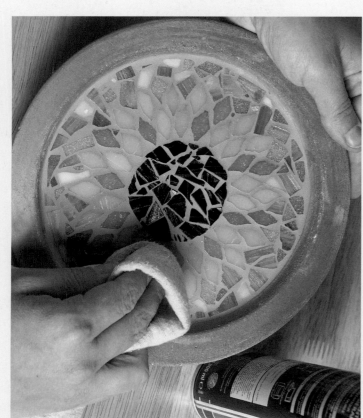

Grout troubleshooting

The following are the most common problems that occur when grouting.

LOOSE TILES

Occasionally, one or two pieces of tile may move or work loose when the grout is applied if they were not glued firmly enough. If this happens, simply apply grout to the base of the tile and put it back in position. Grout acts as a secondary adhesive and should set any loose tiles firmly in place.

using several acrylic paints, it will be almost impossible to achieve an exact match if you need to make another batch, so be sure to mix more than you need.

You cannot apply more grout to a wet mosaic – you must wait until your first grout layer is dry and firm. To apply the extra layer, simply rub the grout (preferably by hand, wearing rubber gloves to avoid any lingering sharp edges) into the gaps to fill the irregularities, then wipe off the excess straight away. You should be able to target just those areas that need attention, rather than cover the whole surface again. Work the grout into the surface with a polishing motion until you are satisfied that there are no cracks or fissures to draw the eye.

DRIED-ON GROUT

If the grout dries too quickly and has set hard on the surface of a glass tiled mosaic, you can use a wire wool scourer, soaked in warm soapy water, to scrub the surface and remove the grout. You will not scratch or damage the glass, but it is hard work.

It is not uncommon for little dots of grout to remain in pinholes and surface creases of the glass tiles after cleaning. These are as a result of tiny imperfections in the glass and will not be noticeable at normal viewing distance.

INCONSISTENCIES IN SURFACES

Sometimes a second grout layer is helpful in levelling the surface. This second grout is useful for correcting any inconsistency, such as tiny air pockets that may appear as the drying process occurs.

If you think that you will require a second grout, be sure to use a coloured grout that will store until needed, such as ready-mixed household grout, or where a new batch can be mixed to exactly the same colour, such as pre-coloured powdered grout (see page 30). If you have mixed a unique colour

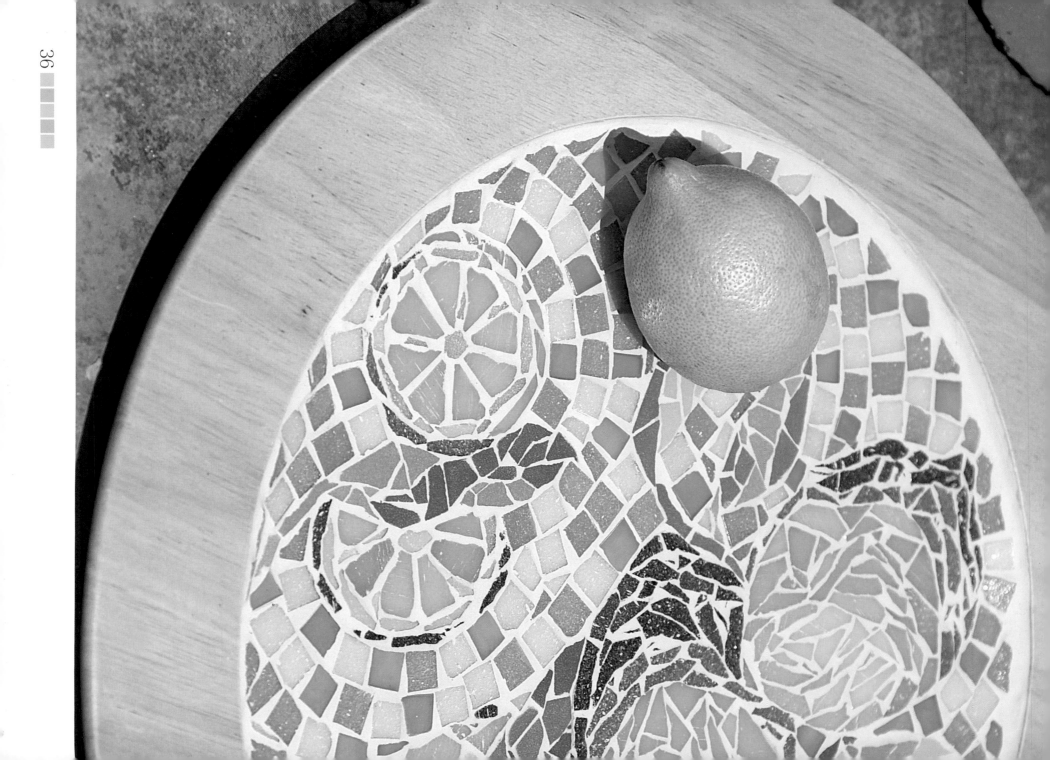

The Projects

Periwinkle handbag mirror

This handbag mirror is as beautiful and striking as it is tactile. It is an excellent gift idea for women of all ages, from teenagers to grandmothers.

YOU WILL NEED vitreous glass mosaic tiles – black, cobalt and lapis blues and mint greens
■ piece of mirror tile, 4.5 x 6cm (1¾ x 2¼in) ■ piece of 4mm (⅛in) plywood, 6.5 x 8.5cm (2½ x 3¼in) ■ PVA (white) adhesive ■ pale mint green-coloured grout (see pages 30–32)
■ sticky-backed plastic

This mosaic design is made with vitreous glass mosaic tiles using the direct method (see page 23). The mirror measures 6.5 x 8.5cm (2½ x 3¼in).

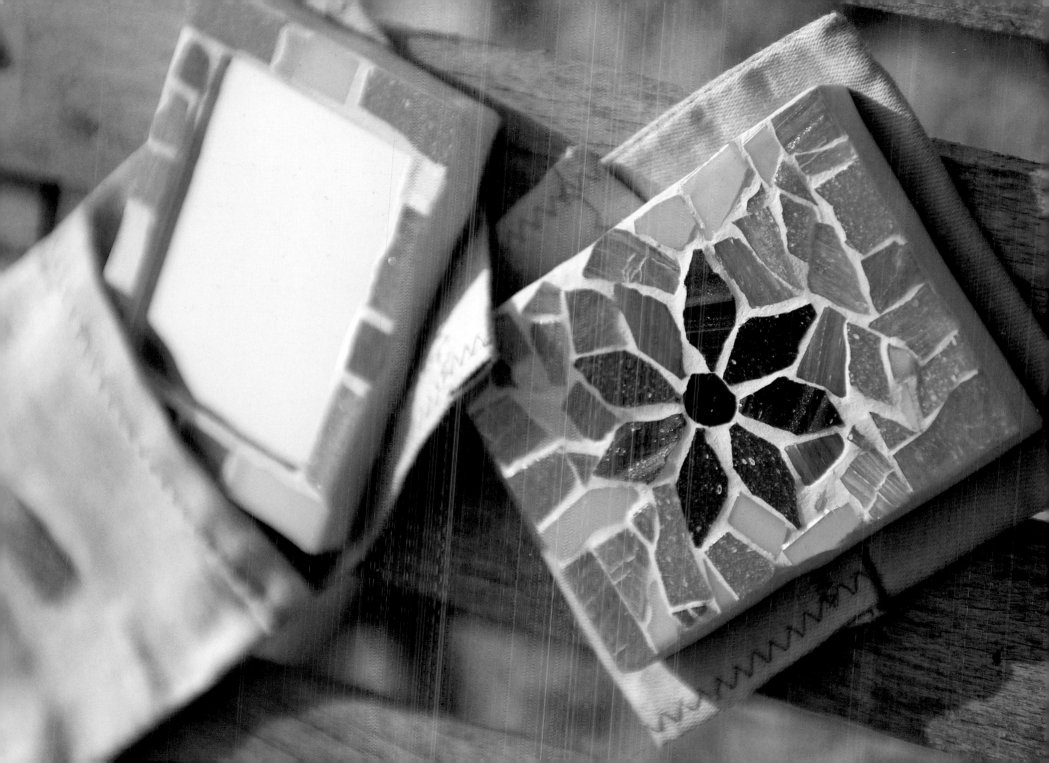

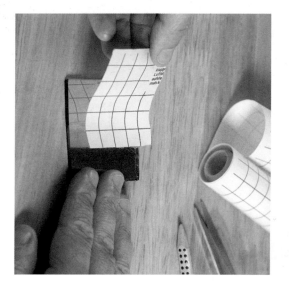

1 Cover the piece of mirror tile with a piece of sticky-backed plastic to protect it from scratches during the process of tiling. Glue the mirror tile to the centre of the plywood with PVA (white) adhesive.

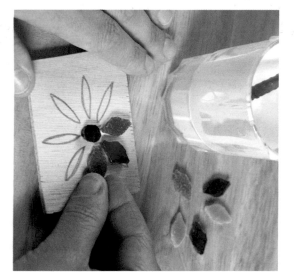

2 Once the mirror has set firmly in place, turn the plywood over. Using the template on page 118, sketch or trace and transfer the periwinkle flower motif onto the surface (see page 15).

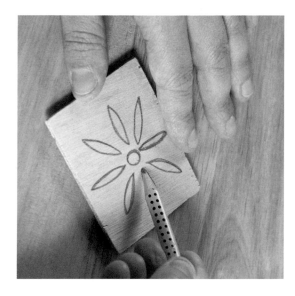

3 Cut a circular piece of black glass tile (see page 19) for the centre of the flower. Then cut eight straight-edged petal shapes (see page 20) from blue glass tiles – use two or three different blues to give the periwinkle added depth. Glue in place with PVA (white) adhesive.

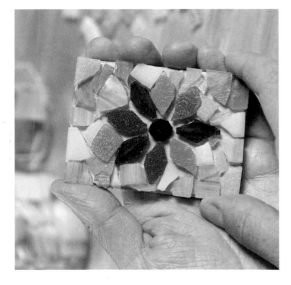

4 Cut a random selection of mint green glass tiles – try to use a mixture of plain and metallic/iridescent tiles to give the background an extra shimmer when moved. Tile around the flower right to the edge of the wood. Leave to dry.

5 Turn the plywood over. Cut more mint green tiles into rectangles by nipping them into halves or quarters (see page 18). Glue the tile pieces around the mirror glass, then leave until completely dry.

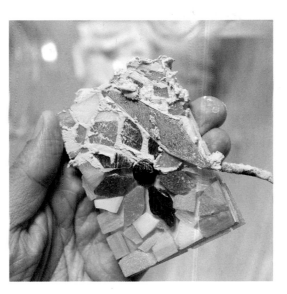

6 Grout the flower side of the mosaic with pale mint green-coloured grout, pressing the grout firmly into the gaps by drawing the knife or spreader across the surface with an even pressure (see pages 33–35).

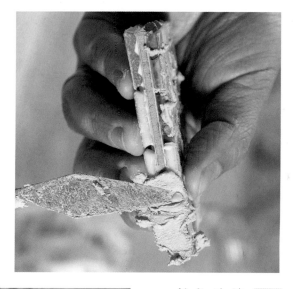

7 Grout the edges of the mosaic in the same way. Leave the mosaic until dry and firm. Remove the sticky-backed plastic from the mirror surface and grout the mirror side and also the edges for a second time (see page 35). Leave to dry completely.

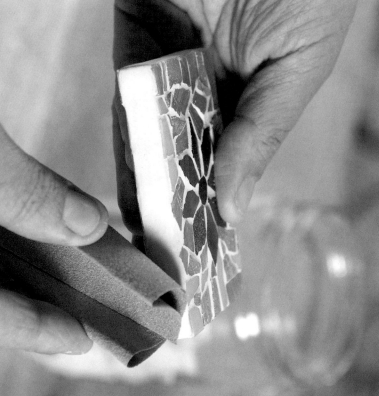

8 Gently sand the edges with fine-grade sandpaper to a smooth finish, and then polish with a soft, clean cloth.

TIP

Why not make a simple pouch in a matching fabric to keep your mirror in, along with a lipstick, such as those shown in the photo opposite and on page 39.

Variations

You can make the handbag mirror in a variety of different designs, such as these stars or hearts (see page 118 for the templates), and in alternative colours.

You can also create hanging decorations for the home or garden using the same technique. Cut square pieces of plywood and drill a small hole in one corner of each. Replace the mirror glass with a second mosaic motif, thread the hole with ribbon, waxed thread or raffia and hang in place.

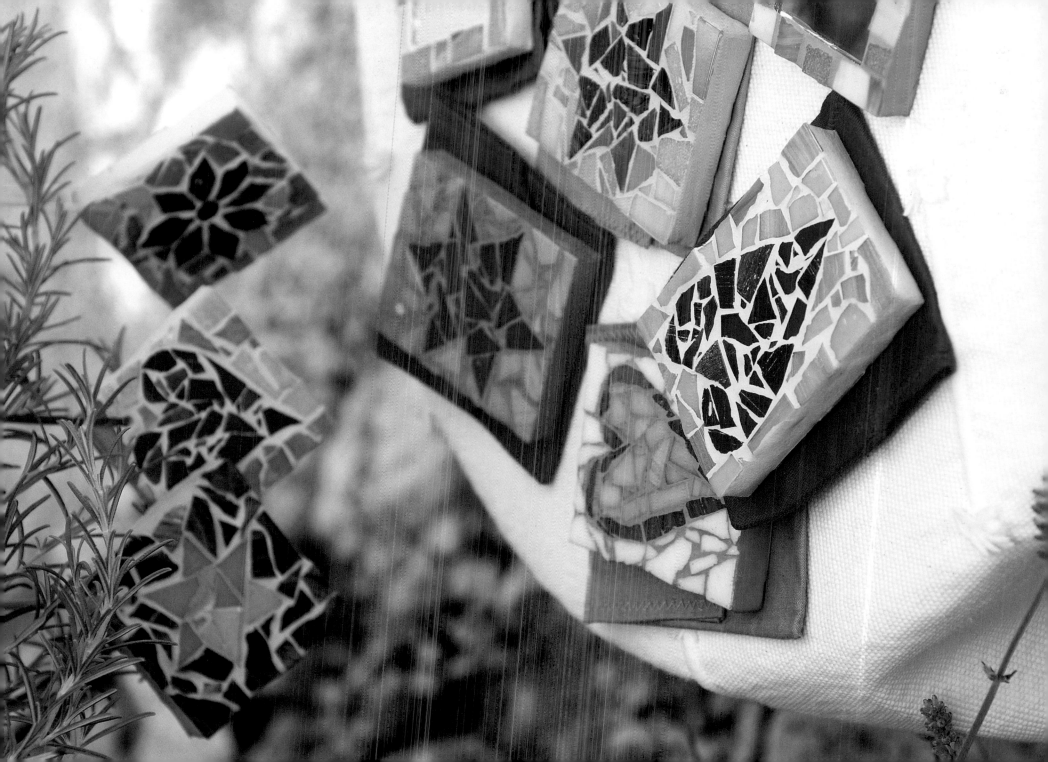

Millefiori jewellery

Mosaic jewellery making is increasing in popularity and many mosaic suppliers (see page 124) now stock a wide range of findings specifically created for mosaic work, enabling you to design your own unique accessories. You can make exquisitely detailed pieces, coordinated to match an outfit for a special occasion, or bold, contemporary 'designer' items. Either way, the wearer is sure to get noticed!

YOU WILL NEED ceramic and glass mosaic tiles in a mixture of colours and effects ■ millefiori beads in a mixture of colours 5–6mm (¼in) in diameter ■ silver-plated oval pendant base with metal fittings and cord, 35 x 50mm (1½ x 2in) ■ pair of silver-plated oval earring bases with ear-hooks, 32 x 45mm (1¼ x 1¾in) ■ silicone adhesive ■ ready-mixed household grout and pigment (see pages 30 and 32) ■ pair of jewellery-making pliers

The mosaic designs are made with ceramic and glass mosaic tiles and millefiori beads using the direct method. The pendant measures 35 x 50mm (1½ x 2in) and the earrings 32 x 45mm (1¼ x 1¾in).

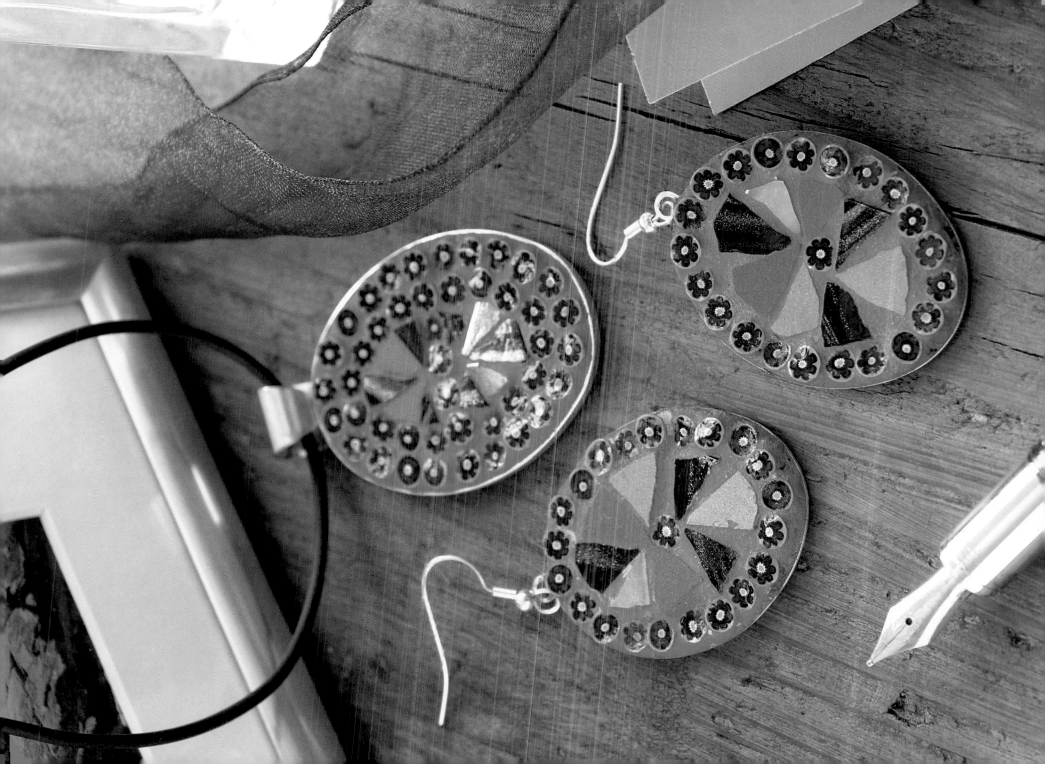

1 Using jewellery-making pliers, separate the fittings and cord from the pendant base, and the ear-hooks from the earring bases. Store in a safe place until you are ready to reassemble the findings.

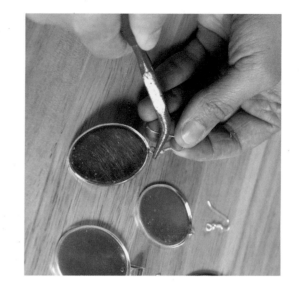

TIP

As the work is detailed and the pieces required are very small, it is advisable to use tweezers to help you place the pieces together more easily.

2 Begin by deciding on your colour scheme and design, and then sort and separate some beads and tiles ready to use. It is useful to keep a small plate or saucer handy so that you can sort through your beads without fear of losing any from the table, as they are very small and can easily be misplaced.

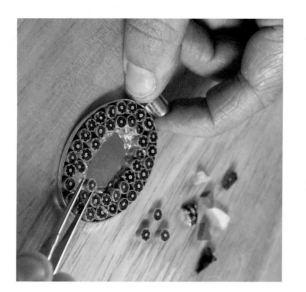

3 In this design, with a turquoise colour scheme, millefiori beads with a small brown flower motif have been selected to form a pattern around the edge of the pendant. These are then glued into place with silicone adhesive. It is important to make sure that they are spaced evenly and fitted snugly up to the raised rim of the base. Two rows of these beads form a frame and then a further three beads are added to form a row across the centre.

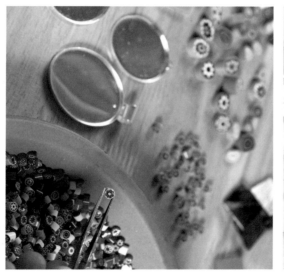

4 Some small triangular pieces of ceramic and glass tiles, in matching turquoise and brown tones, are then cut (see page 18) and glued in a pattern out from the centre bead.

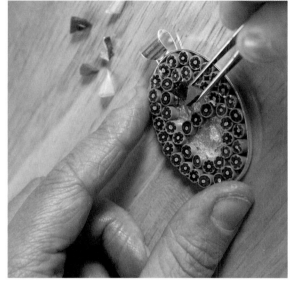

5 The earrings are made in the same way to complement the pendant. The design is varied slightly, with just one framing row of small millefiori beads around the edge and one central bead

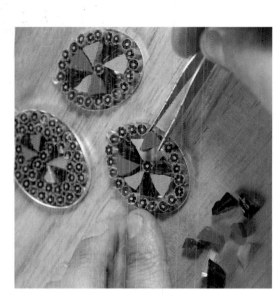

6 More small triangular pieces of ceramic and glass tiles are then added to fill the centre of the earring design. Colour ready-mixed household grout with a pigment that will maintain the desired colour effect of the pieces (see pages 28–29 and 32). Press the grout into the tiny gaps between the tiles, using the tip of a pointed palette knife to carefully embed the beads (see pages 33–35).

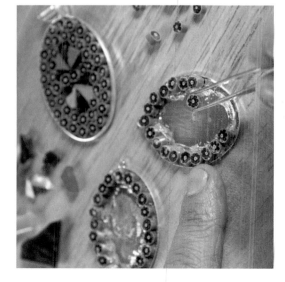

TIP

It is preferable to make a pair of earrings or other matching accessories simultaneously. The pieces must be evenly sized on both earrings and the pattern either identical or, as with these earrings, a mirror image of each other. Although it is impossible to cut two pieces exactly alike, similar-sized pieces will look almost the same when worn.

Variations

This asymmetrically designed pendant features a large glass gem bead set into a background of randomly cut triangular glass tiles, interspersed with different-sized millefiori beads in a mixture of bright blues and yellows.

Bold and distinctive, these rings make a stylish statement. In the middle example, square and rectangular shapes fit together to form a tight, solid design, while the two oblong rings use only five or six elements to striking effect.

TIP

As such small amounts of grout are required, it is best to use ready-mixed grout coloured with pigment (see page 32), as this can be mixed together very effectively in tiny quantities.

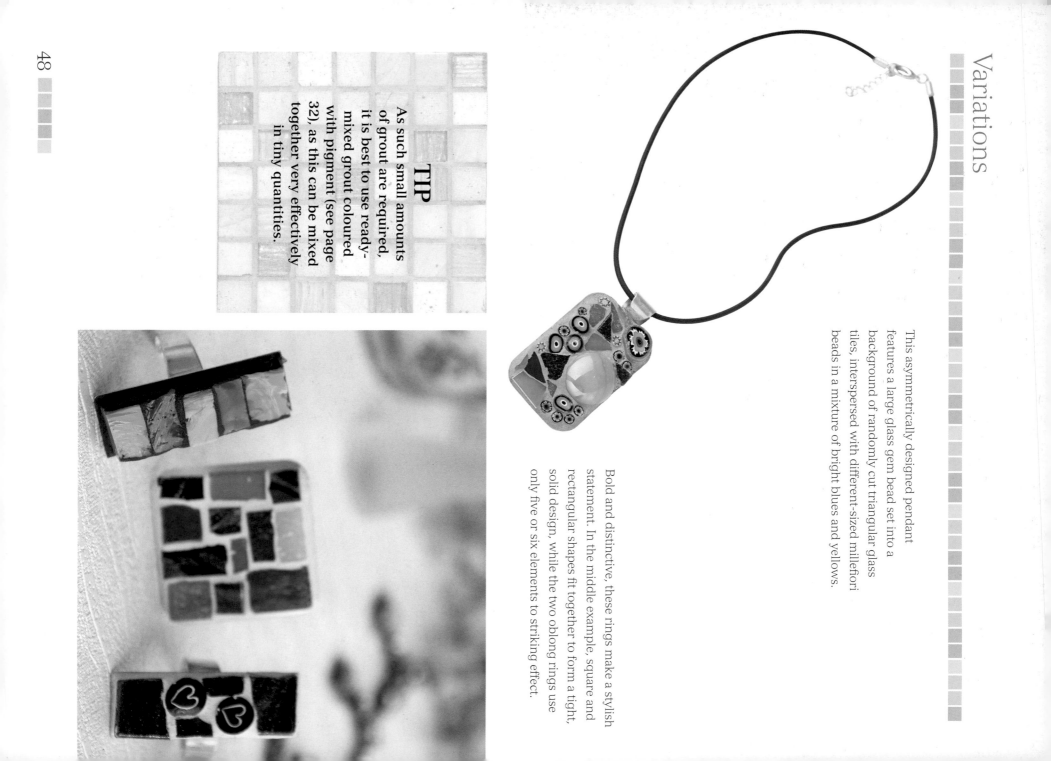

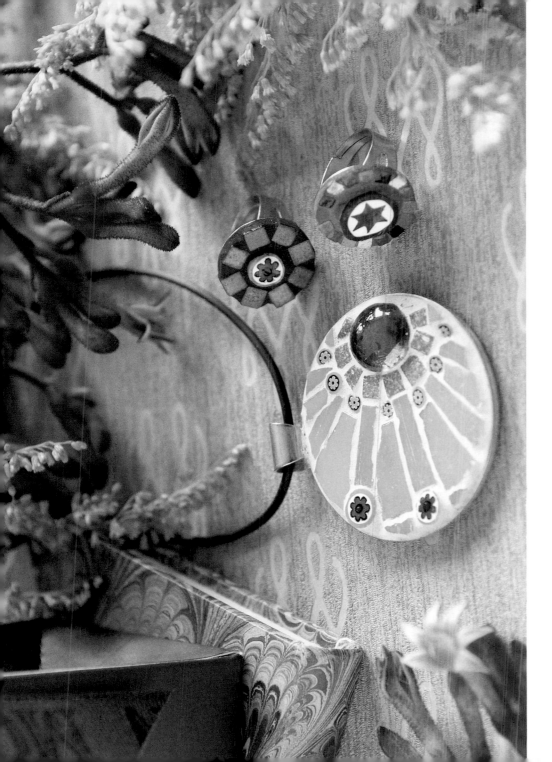

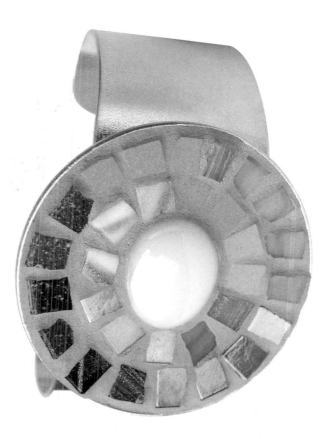

This glitzy sunray pendant combines an amber glass gem bead with two-toned golden yellow tile strips and millefiori beads. The autumnal ring designs, based around a central bead motif, are finished in a warm brown grout.

For this tactile bracelet, tiles of subtly changing hue, from light pink to deep purple, are set in mauve grout around a glass gem bead. A mixture of gold threaded and iridescent tiles excites the eye and varies the surface depth.

Flower-studded jewellery box

This jewellery box is both attractive and practical. The base of the box is simply painted in a contrasting colour to allow the richness of the pattern on the lid to be enjoyed to the full.

YOU WILL NEED mini mosaic tiles – lemon yellow and ochre ■ vitreous glass mosaic tiles – lemon and deep yellow, orange, blue and red ■ ceramic mosaic tiles – pale and dark blue ■ opaque and translucent millefiori beads, 11–13mm (½in) in diameter – yellow, red and orange ■ round wooden box with lid, 17cm (6¾in) in diameter ■ PVA (white) adhesive ■ pale lemon-coloured grout (see pages 30–32) ■ blue matt paint ■ sticky-backed felt or velvet

The mosaic is made with a combination of vitreous glass and ceramic mosaic tiles, plus a few millefiori beads for the pattern, using the direct method (see page 23). The box measures 17cm (6¾in) in diameter.

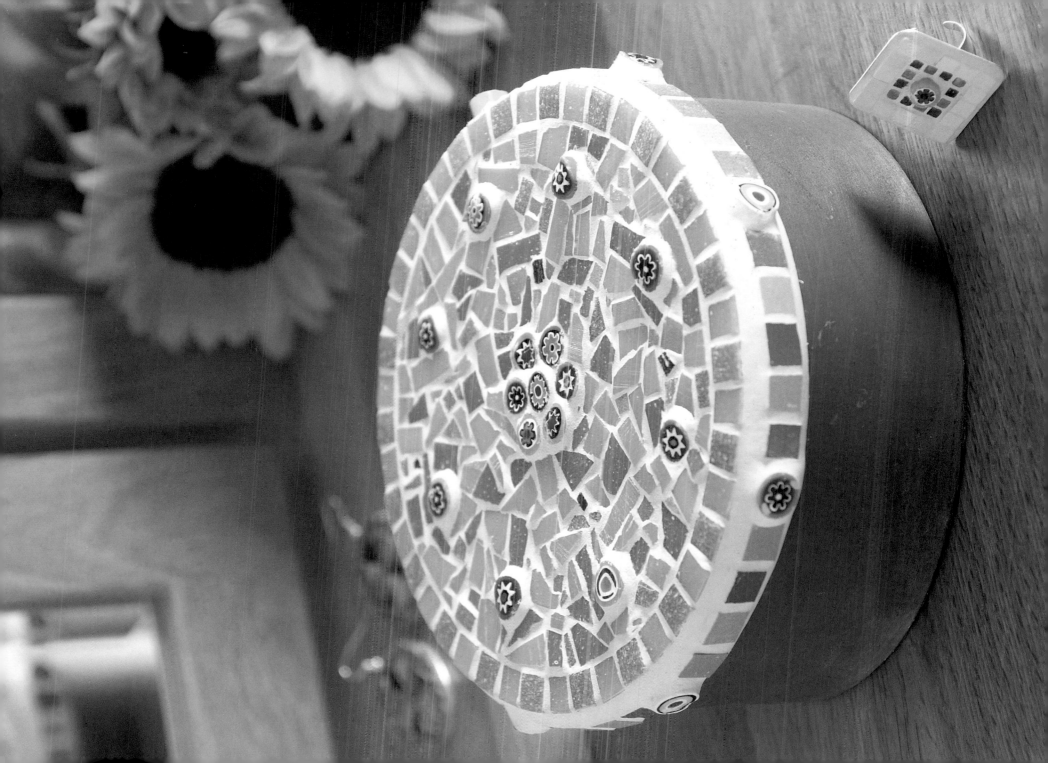

Flower-studded jewellery box

1 To seal the box, brush all over with a solution of diluted PVA (white) adhesive (one part PVA/white adhesive to five parts water) and leave to dry.

2 Glue a cluster of seven millefiori beads onto the centre of the lid. Brush just a small circle of glue into the centre of the lid, rather than all over the surface, as this will avoid the glue drying too quickly on the parts of the lid that are tiled at later stages.

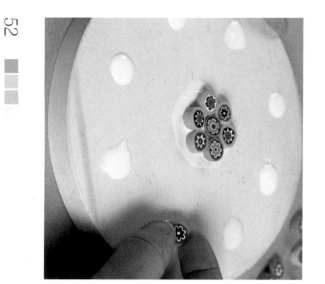

3 Glue a further eight beads in a ring surrounding the central beads, again carefully applying a thick spot of glue at evenly spaced intervals.

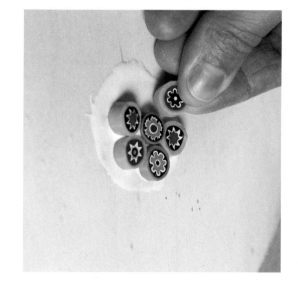

4 Glue a circle of mini mosaic tiles around the outer edge of the lid, using alternate lemon yellow and ochre tiles, spacing them evenly to form a circle.

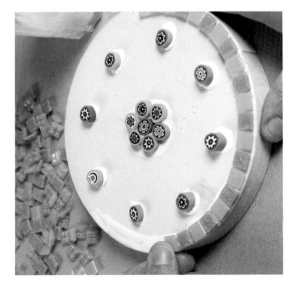

5 Now fill the gap between the beads and the tiled edging with randomly cut glass tiles in a mix of yellows and oranges, with a few flecks of blue and red tiles interspersed for additional interest.

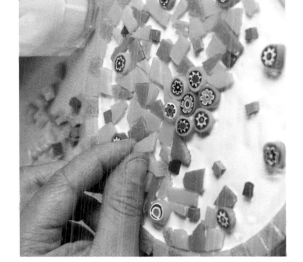

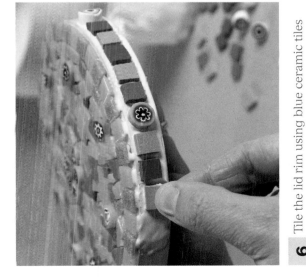

6 Tile the lid rim using blue ceramic tiles cut into quarters (see page 18), with eight millefiori beads glued at evenly spaced intervals between them. Grout with pale lemon-coloured grout, making sure that it goes all the way over the edge to meet the wood (see pages 33–35). Smooth the grout edge with a damp cloth for a neat finish.

TIP
These boxes make an excellent gift idea. Why not fill them with chocolates as an added edible treat.

7 Paint the base of the box with one or two coats of blue matt paint to cover and leave to dry.

TIP

Millefiori glass beads vary in depth, from 3–6mm (⅛–¼in), so might be slightly raised or recessed compared to the regular mosaic tiles, which are 3mm (⅛in) thick. When grouting uneven surfaces, use the pointed tip of the palette knife to press the grout deeply into the gaps and carefully 'scoop' the grout around the raised beads to embed them.

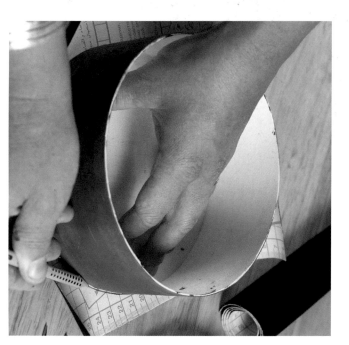

8 Cut a circle of sticky-backed felt or velvet to fit the bottom of the box base and stick in place. This will help to avoid scratching your household surfaces and give the box a professional finish.

Variation

The mosaic on the chunky star-shaped box opposite has been continued over the sides, and tiny pieces of mirror tile have been embedded into the design for a touch of extra sparkle.

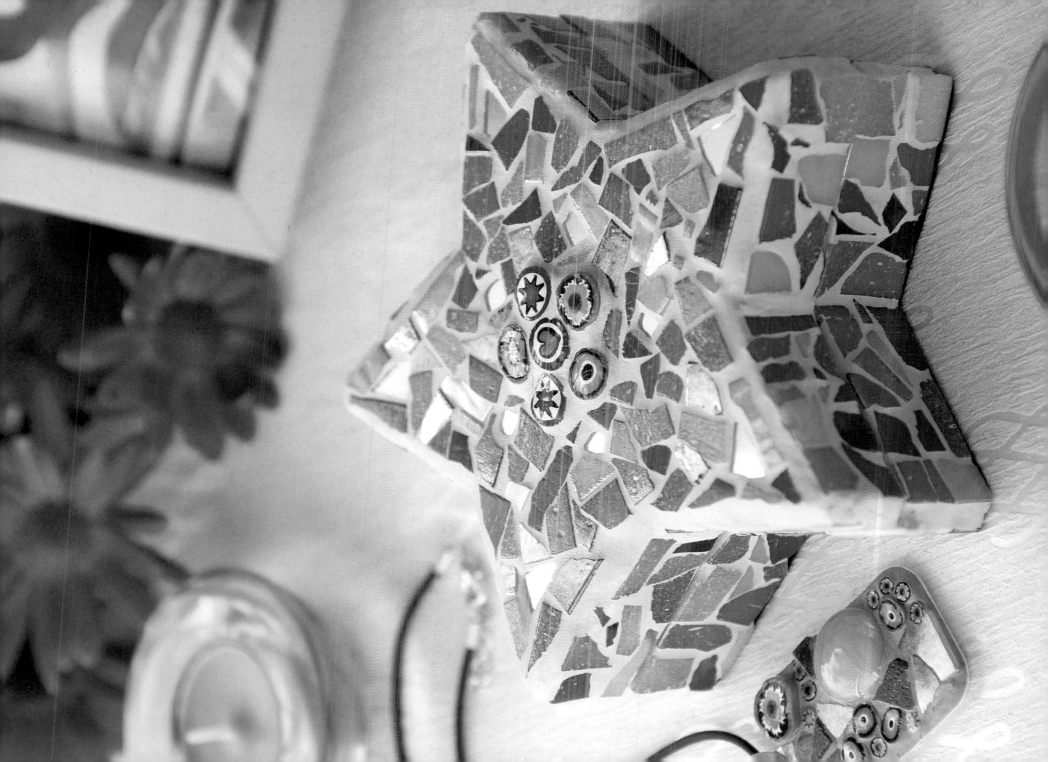

Hotpot stand and coasters

With contemporary and alluring colours in a bold pattern, these mats are fully heat-resistant, washable and fitted with a felt or velvet base for a non-scratch finish. Since you can choose from a virtually limitless range of colour combinations, they can be made to match any room interior or tableware.

YOU WILL NEED vitreous glass mosaic tiles in a mixture of colours and effects, 2cm (¾in) square ■ piece of 12mm (½in) plywood, 20cm (8in) square ■ six pieces of 6mm (¼in) plywood, 8.5cm (3¼in) square ■ PVA (white) adhesive ■ coloured powdered grout (see pages 28–32) ■ gloss paint ■ sticky-backed felt or velvet

Made with vitreous glass mosaic tiles using the direct method (see page 23), no tile cutting is involved in creating these mats. The hotpot stand measures 20cm (8in) square and comprises 81 tiles (9 x 9 tiles), while the coasters measure 8.5cm (3¼in) square and each have 16 tiles (4 x 4 tiles).

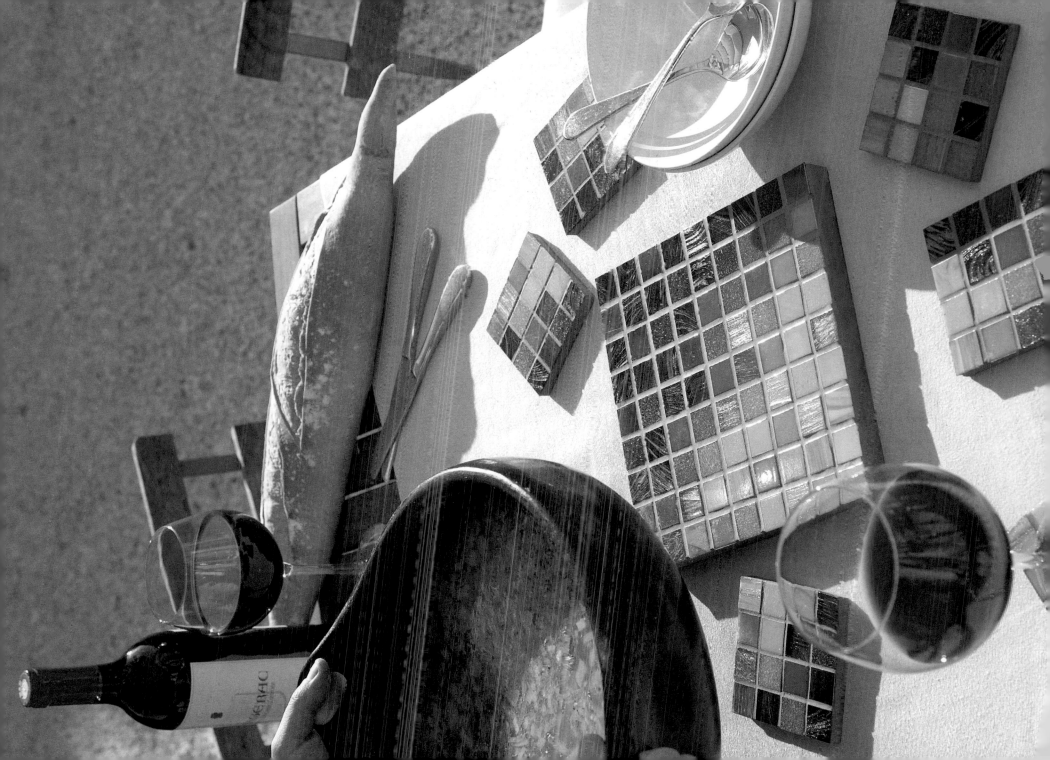

1 For the hotpot stand, choose 81 whole mosaic tiles to form the pattern. Begin by selecting your colour scheme (see page 14). Here, a plum/burgundy theme was chosen and a mixture of plain, iridescent, metallic gold and marbleized tiles selected in a variety of harmonious colours. Deep purple- and walnut-coloured tiles have been mixed with copper, lilac, rose pinks and mauves to add tonal changes and excite the eye. Before you start to glue the tiles to the plywood, take time to experiment with the placement of the colours and different combinations.

2 When you have chosen your tiles, spread the larger square of plywood with PVA (white) adhesive and start by tiling the first row across the top of the wood and the first row down the side, as this will help you to space out the tiles evenly over the whole surface.

3 Continue tiling the surface, taking the tiles right to the edge of the wood. Keep the gaps even and the corners of the tiles parallel to each other to form a regular grid. When you have finished tiling the entire surface, leave to dry.

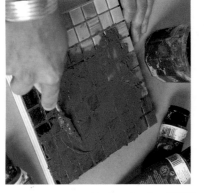

4 Grout in the usual way with suitably coloured powdered grout, making sure that the grout goes around the edges to fill the gaps between the tiles and the wood (see pages 33–35).

TIP

It is a good idea to choose the grout colour at the same time as choosing your tile colours. Remember that the tiles will change colour when they absorb the colour from the surrounding grout, and this will affect the overall look of your hotpot stand and coasters (see pages 28–29).

5 Gently sand the edges with fine-grade sandpaper to a smooth finish.

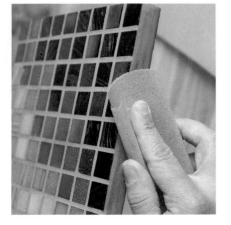

6 Apply a coat of gloss paint to the back to seal the wood, for extra protection. Cut a square of sticky-backed felt or velvet to fit the bottom of the stand. This will help avoid scratching your household surfaces and give it a neat finish.

The coasters are made in the same way using 16 tiles each and the six smaller squares of plywood. Each one is fitted with four sticky-backed felt or velvet feet on the bottom to finish. The tiles are arranged in varying configurations to create a mix-and-match set.

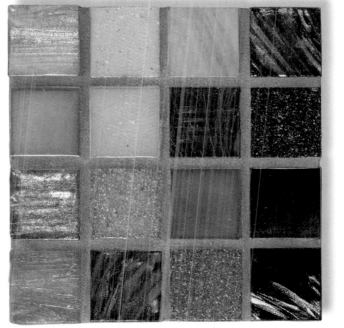

Variations

Here you can see some examples of different colour schemes and patterns for coasters. You can easily mix grout colours that complement your furnishings (see pages 28–29), or choose combinations of tile colours that will harmonize with your table setting.

Daisy napkin rings

Tactile, bright and fresh, these napkin rings are perfect for either indoor or outdoor dining areas, and are sure to provide a talking point at any lunch or dinner party. The tile colours can easily be adapted to tone with your favourite table linen.

YOU WILL NEED vitreous glass mosaic tiles – yellow, iridescent and plain white and turquoise blues ■ 2 pieces of plastic plumbing pipe, 6cm (2¼in) in length and 4cm (1½in) in diameter ■ PVC gel adhesive ■ pale blue-coloured grout (see pages 30–32)

The mosaic designs are made with vitreous glass mosaic tiles using the direct method (see page 23) and glued onto plastic plumbing pipe with PVC gel adhesive, available from hardware or plumbing stores. The rings measure 6cm (2¼in) in length and 4cm (1½in) in diameter.

1 Cut a circle of yellow glass tile (see page 19) for the centre of the daisy and nine rounded petal shapes (see page 20) from a mixture of plain and iridescent white tiles for the flower motif. Glue them in place on the pieces of plastic plumbing pipe with the PVC gel adhesive.

2 Cut a mixture of blue tiles for the background and glue these onto the pipe, working on a small area at a time and allowing the glue to set before rotating the pipe to tile the next section. Tile right to the edge of the pipe.

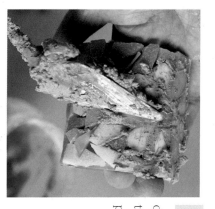

3 Grout the mosaic and its edges, taking the grout right over the edge to fill the gap between the plastic pipe and the tiles (see pages 33–35).

4 Smooth the grout at the edges of the tube with a damp cloth for a neat finish.

TIP

PVC gel adhesive is best used in a well-ventilated room, as the fumes can be quite powerful. It dries very quickly, usually within ten minutes.

Variation

Keep your tablecloth from flying away by attaching a leaf-shaped clip to each corner. They are simply made by gluing large curtain clips to a plywood base shape (see page 118 for the template). A few green millefiori beads have been added for extra detail. They can be also used as napkin rings, by threading the napkin through the rounded clip.

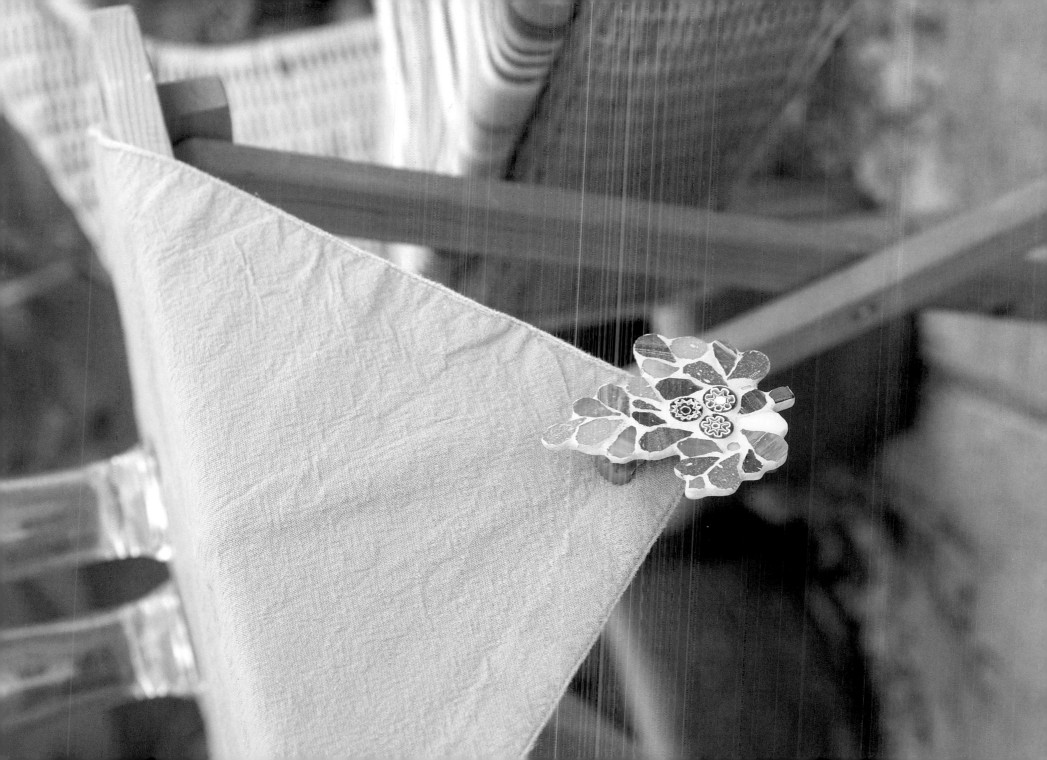

Hot chilli tray

This stylish serving tray features a hot chilli pepper motif set against a warm Mediterranean blue background. The black outline around the chillies helps to frame them and give them extra definition in relation to the surrounding intense lapis and azure blue tones.

YOU WILL NEED vitreous glass mosaic tiles – rich reds, black, deep greens and lapis and azure blues ■ wooden tray base, 35 x 45cm (14 x 18in) ■ brown craft paper ■ blue matt paint ■ PVA (white) adhesive ■ dark grey grout adhesive (see page 11) ■ dark grey-coloured grout (pages 30–32) ■ masking tape ■ 3mm (⅛in) notched trowel or comb

The mosaic is made with vitreous glass mosaic tiles using the indirect or reverse method (see pages 24–25), to ensure that it is flat and smooth for carrying drinks safely, and is finished with blue matt paint around the tray edges. The tray measures 35 x 45cm (14 x 18in).

1 Using the template on page 118, sketch the chilli design onto paper or photocopy onto paper and colour in (see page 15). Then sketch or trace the design onto tracing paper.

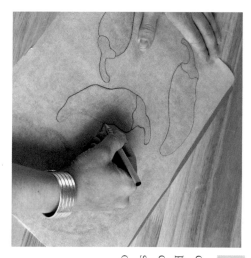

2 Cut a piece of brown craft paper to fit the bottom of the tray. Place the tracing paper upside down onto the brown paper and secure in place with pieces of masking tape. Re-draw around the images to transfer them, in reverse, onto the brown paper. Remove the tracing paper. Go back over the lines of the images again to make them dark and clear.

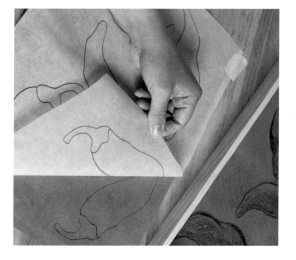

3 Paint the edges of the tray with blue matt paint, to seal the wood and frame the finished mosaic. Set the tray aside to dry while you tile the base.

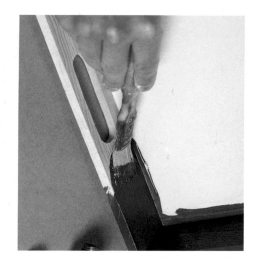

Variation

This wooden platter with a lemon motif (see page 119 for the template) is made in the same way as the tray. Mosaic platters make excellent serving plates for fruit or cheeses, as they are easy to keep clean by washing with hot, soapy water without risk of damaging the mosaic.

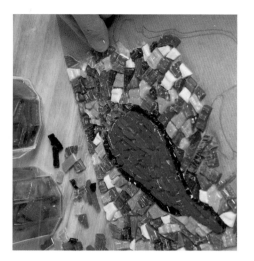

4 Using a solution of diluted PVA (white) adhesive (one part PVA/ white adhesive to one part water), tile the chillies onto the paper (see page 24). Remember that you are creating the pattern in reverse and therefore you must glue all the tiles smooth-side down. The chillies can be made to look more rounded by varying the reds from dark to pale over their surface (refer to the template on page 118 as a guide). An undulating black outline to each chilli provides extra clarity. Tile the background with a mix of blues until all the paper is filled. Try to keep the gaps evenly spaced over the whole surface. Leave to dry completely.

5 To transfer the mosaic to the tray, spread a layer of the grout adhesive onto the base, using the notched trowel or comb to give the surface a good key. Turn the paper over and press the tiles firmly and evenly to embed them in the adhesive and make sure that the surface is flat. Leave to dry. Soak a sponge in warm water and wet the surface of the paper, allowing the water to soak through and dissolve the glue. Starting at one corner, peel the paper gently from the tiles – it should lift off very easily. If it tears or is difficult to remove, dampen again and wait for a few minutes. Once the paper has been removed, your mosaic will be the right way up and is ready for grouting in the usual way with dark grey-coloured grout (see pages 33–35) Polish with a soft, clean cloth.

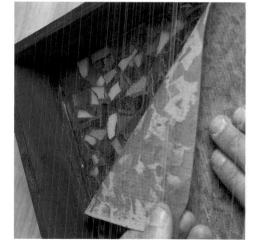

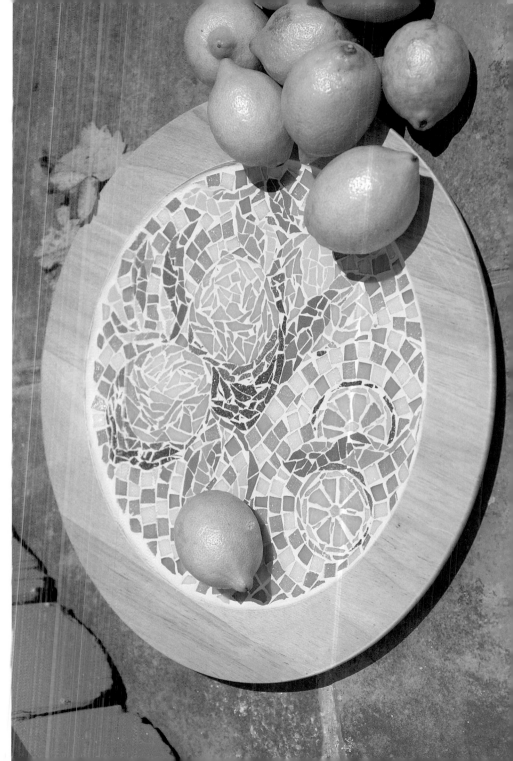

Rooster bookends

Farmyard animals are always a delightful addition to a kitchen setting, and whether you have a rustic country-style or modern one, these whimsical chicken bookends will look great propping up your cookery books. The books are placed on top of the mosaic bases between the roosters in order to give them added weight and stability.

YOU WILL NEED ceramic and vitreous glass mosaic tiles – black, reds, orange, yellow, white, greys and greens ■ 19mm (¾in) plywood or chipboard – 2 base pieces 20cm (8in) square and 2 upright pieces 24 x 20cm (9½ x 8in) ■ PVA (white) adhesive ■ white grout (see pages 30–31) ■ sticky-backed felt or velvet

The mosaic designs are made with ceramic and vitreous glass mosaic tiles using the direct method (see page 23). The bookends measure 24 x 20cm (9½ x 8in).

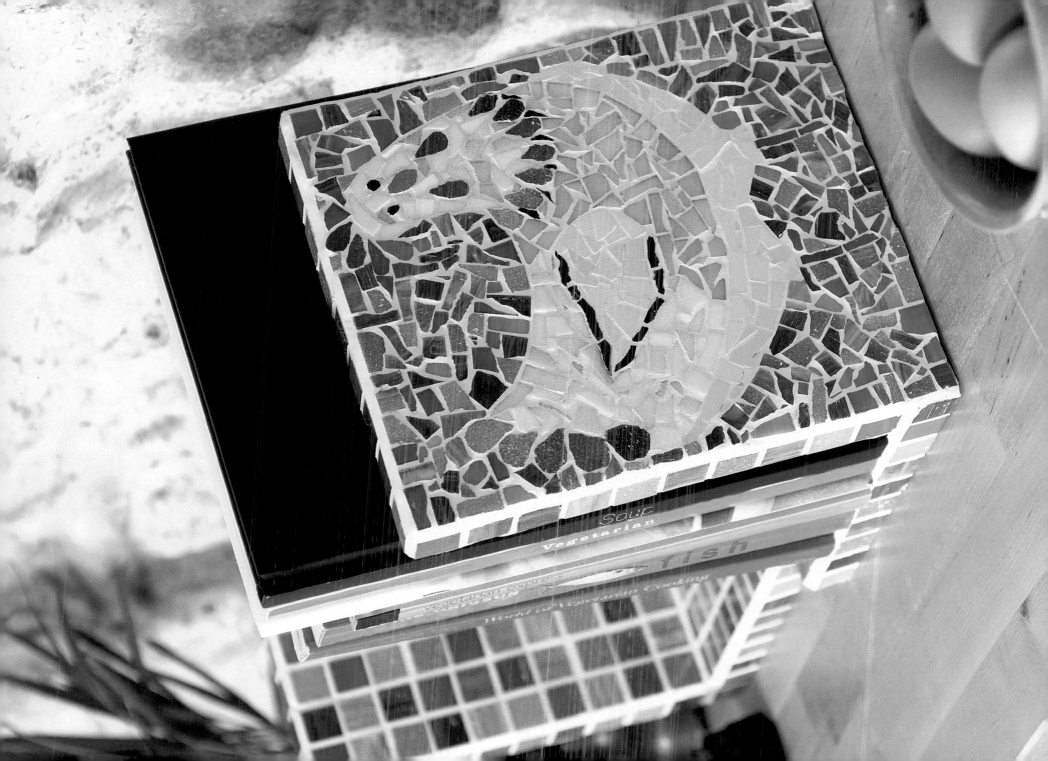

1 Place each square base piece of plywood or chipboard together with an upright rectangular piece of plywood or chipboard to form a right angle. Using a drill and 3.5mm (⅛in) drill bit, secure each pair of pieces in place with three woodscrews.

2 Using the templates on page 119, sketch or trace and transfer one of the chicken motifs onto each of the uprights (see page 15). Using colouring pencils, mark out the different shaded areas and colour gradations over the body of each chicken to help define the shadow on the underside of the chicken and below the neck feathers.

3 Start by cutting the black circles (see page 19) for the eyes, and the oval and petal shapes (see page 20) for the beak and plumage. Glue the tile pieces in place with PVA (white) adhesive.

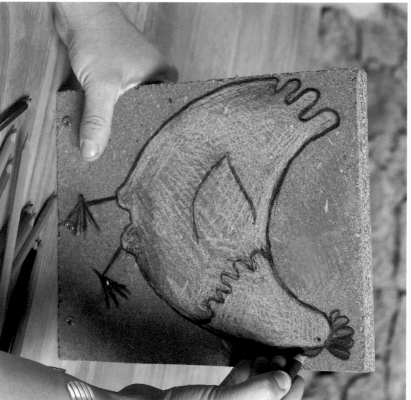

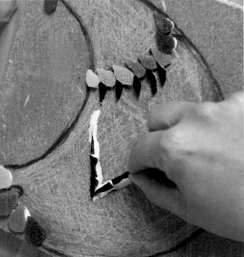

4 To give the chickens' neck feathers extra definition, cut some black tiles into thin lines (see page 18) and place them between the petal-shaped tiles. Define the wing features of each chicken in the same way with a line of thin black tiles.

5 Tile the chickens carefully, following the outline of the bodies. Try to keep a precise line by using the clean, uncut sides of tiles to create a sharp edge. A mixture of white and grey tiles will help to emphasize the shading over the bodies, and a combination of ceramic and glass will give extra depth to the design (refer to the template on page 119 as a guide). Cut the tail shapes by rounding the edges of the tiles to form soft curves. Cut thin strips for the legs and feet.

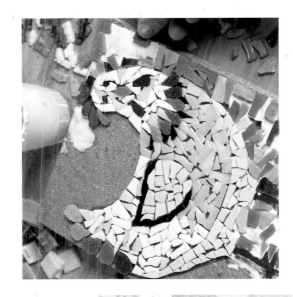

6 Fill the background with a mixture of greens, tiling right to the edge.

TIP

There is no need to colour the grout for these bookends, as using white grout will give the shape of the chicken extra solidity and bring a clean look to the overall design.

7 Tile the bases with whole green tiles in a mixture of different shades until the entire surface is covered.

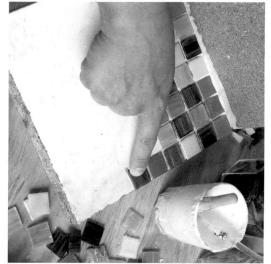

8 Tile the edges of the bases in the same way, then tile the edges of the uprights and the exposed edges. Leave the mosaics to dry completely.

9 Grout in the usual way (see pages 33–35). Press the grout firmly around all the edges and joints to seal. Leave to dry completely, then polish with a soft, clean cloth. Cut a square of sticky-backed felt or velvet and attach to the bottom of the bases, to help avoid scratching your shelves and to give them a neat finish.

Variation

This duck doorstop (see page 119 for the template) has been made in the same way as the bookends, but in this case the flat base board has been substituted by a plinth. The weight of the mosaic tiles combined with the solid block of wood forms a very stable structure that will not tip over easily.

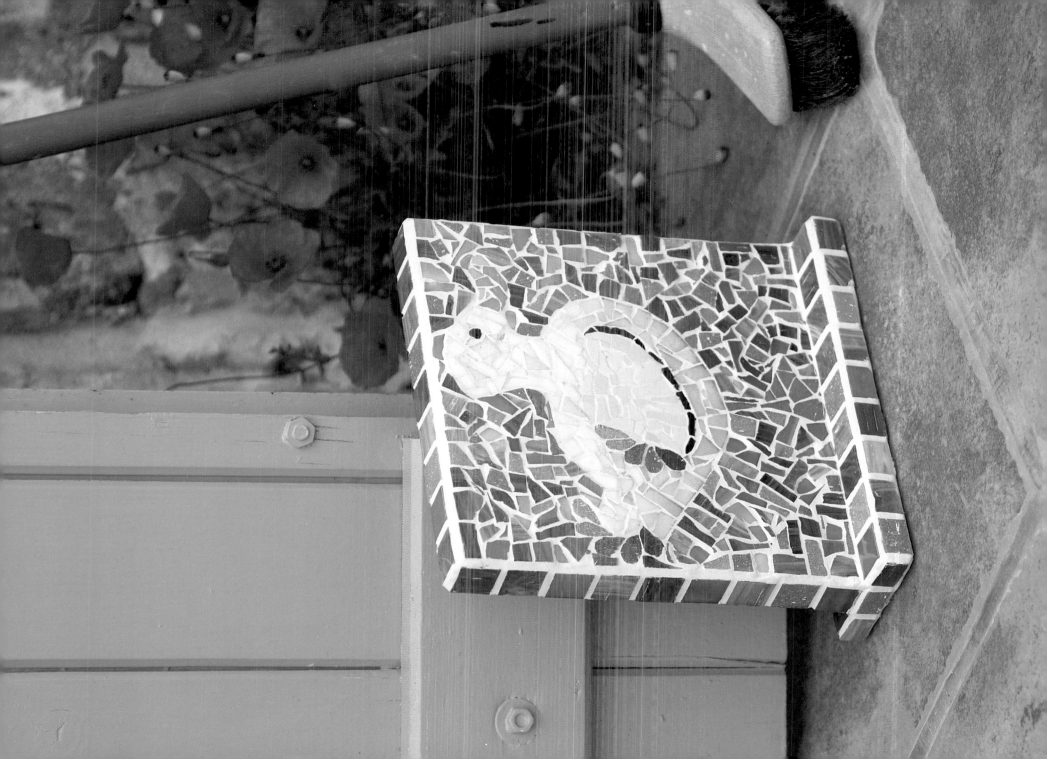

Seahorse wall decoration

This wall decoration is perfect for livening up your bathroom. Made in neutral colours, from cream to copper, it is subtle and elegant. Tonal colour gradation is used in this project to give the seahorse form and to define light and shade over the body, while the triangular or angle-cut tiles give it a lively, spiky finish.

YOU WILL NEED vitreous glass mosaic tiles – black, copper, cream, ochre, caramel and brown ■ piece of 6mm (¼in) MDF, 50 x 20in (20 x 8in), or a pre-cut MDF seahorse shape (see page 9) ■ household wood filler (optional) ■ PVA (white) adhesive ■ cream-coloured grout (see pages 30–32) ■ cream gloss paint (optional) ■ 'D'-ring fitting and screws

Many craft stores stock pre-cut MDF seahorse shapes, which will save on complicated wood cutting. The mosaic is made with vitreous glass tiles using the direct method (see page 23), and the seahorse measures 43 x 13cm (17 x 5in) at its longest edges.

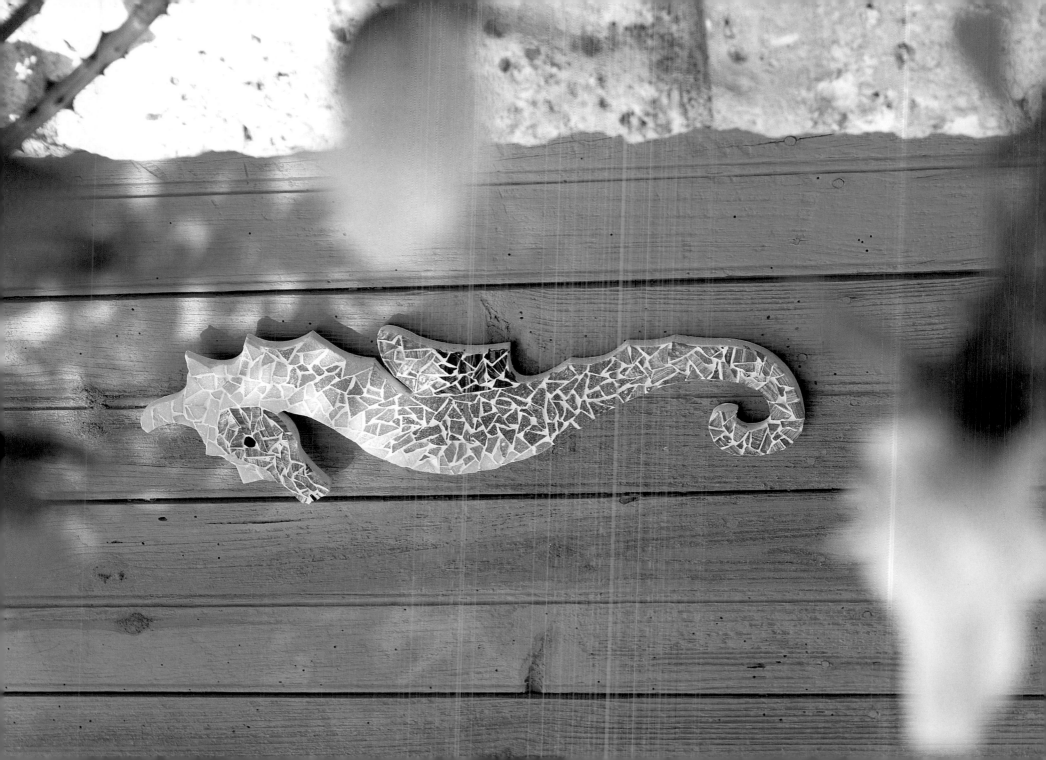

1 If not using a pre-cut MDF seahorse shape, using the template on page 120, sketch or trace and transfer the seahorse onto the piece of MDF (see page 15) and then cut out with a scroll saw. To seal the surface of the MDF, brush all over with a solution of diluted PVA (white) adhesive (one part PVA/white adhesive to five parts water). Leave to dry.

2 MDF shapes are often manufactured with some cutout features, like this one, which has a hole for the eye. To be able to mosaic over these missing sections easily, apply some household wood filler to close the hole. Once the filler has set hard, gently sand the surface smooth with fine-grade sandpaper.

3 Draw the fin and face sections onto the shape. Using colouring pencils or wax crayons, sketch the various different shaded areas onto the body to help define the tonal changes. Start by shaping a piece of black tile for the eye (see page 19) and glue in place. Using PVA (white) adhesive, tile a section at a time, working downwards to the tail. This will prevent you accidentally dislodging already tiled sections by stretching or leaning over to reach higher untiled sections.

4 When you have finished tiling the entire surface of the seahorse, leave the adhesive to dry completely.

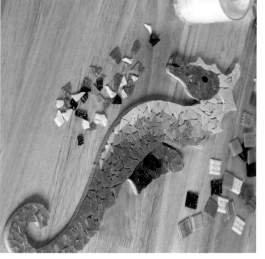

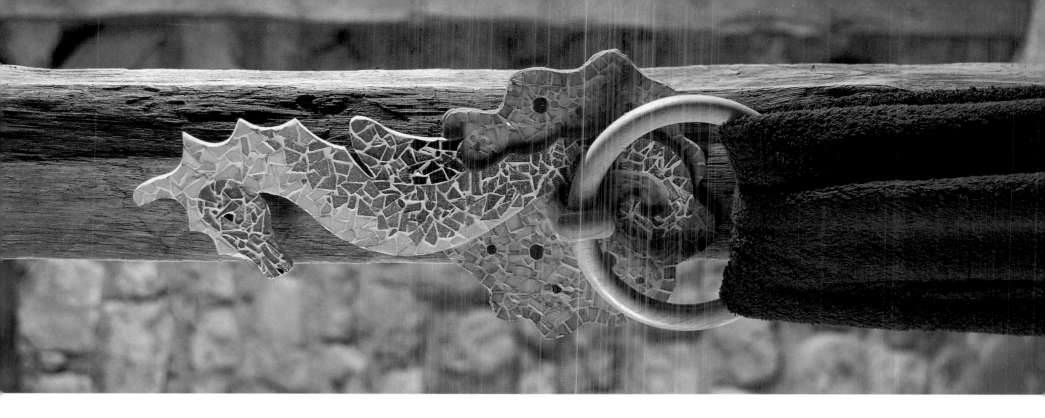

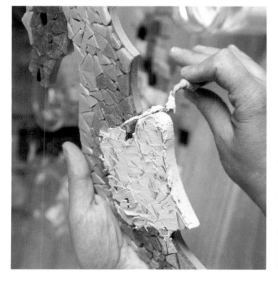

5 Grout the seahorse with cream-coloured grout, taking the grout over the edges to seal the gaps between the tiles and the wood (see pages 33–35). Leave the grout to dry completely, then lightly sand around the edge to a smooth finish with fine-grade sandpaper.

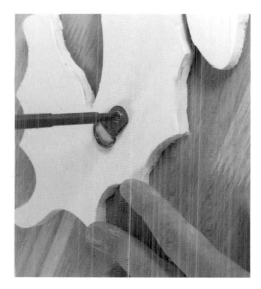

6 If your bathroom is very humid, apply a coat of cream gloss paint to the back of the seahorse for added protection. Attach a 'D'-ring fitting to hang, making holes for the screws with an awl.

Variation

Once you have made your seahorse, it can be turned into other fun bathroom accessories, such as this towel ring. Here, the finished seahorse has been mounted onto a shaped back plate with a wooden towel ring attachment, which has then been tiled with a swirled sea pattern and finished in a different-coloured grout.

Tropical fish toothbrush holder

Fresh and fun mosaic accessories will brighten up even the smallest bathroom and can withstand extremely humid conditions, such as those found in shower rooms. This project uses a combination of grout colours to give an extra dimension to the mosaic. It is made by appliquéing a completed fish mosaic onto a base and then adding another mosaic around it, using a different grout colour.

YOU WILL NEED vitreous glass mosaic tiles – black, yellow, orange, red, turquoise/light blues and purple/deep blues ■ two pieces of 19mm (¾in) chipboard, 3 x 11cm (1 x 4½in) and 18cm (7in) square ■ 6mm (¼in) plywood, 10 x 15cm (4 x 6in) ■ chrome toothbrush holder to hold a glass and 6 toothbrushes ■ PVA (white) adhesive ■ sky blue- and indigo-coloured grouts (see pages 30–32) ■ strong wood glue ■ blue gloss paint ■ metal hanging plate and screws

The mosaic is made with vitreous glass mosaic tiles using the direct method (see page 23), and the holder measures 18 x 18 x 2cm (7 x 7 x ¾in).

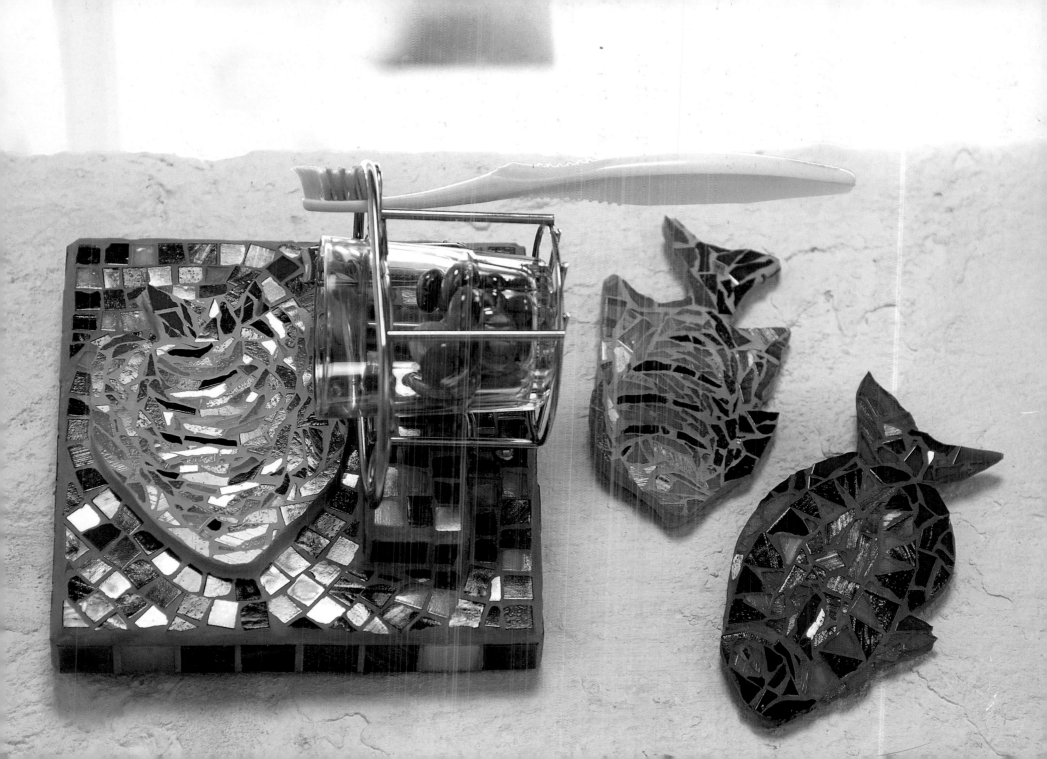

1 Position the strip of chipboard (for the plinth) centrally on the chipboard square (for the backboard), 2cm (¾in) up from the bottom of the square. Using a drill and 3.5mm (⅛in) drill bit, secure in place with two woodscrews, then drill a pilot hole in the centre of the strip for the holder attachment.

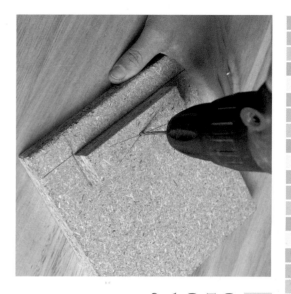

2 Using the template on page 120, sketch or trace and transfer the fish design onto the piece of plywood (see page 15). Cut out with a scroll saw. Lightly sand around the edge of the fish with fine-grade sandpaper to remove any splinters. Apply a layer of a solution of diluted PVA (white) adhesive (one part PVA/white adhesive to five parts water) to seal the surface and leave to dry.

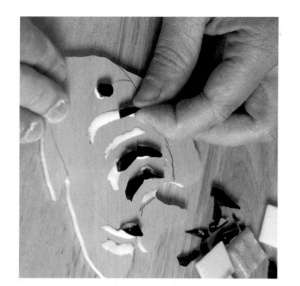

3 Using PVA (white) adhesive, begin tiling the fish by cutting a black circle (see page 19) for the eye and some fine black lines (see page 18) for the body pattern.

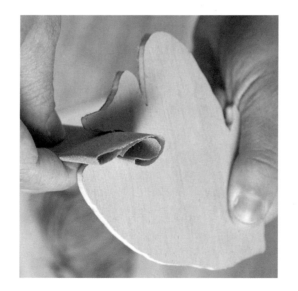

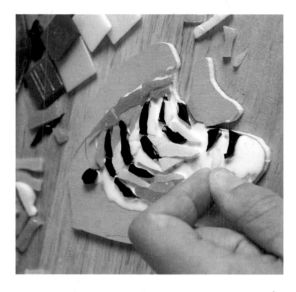

4 Use plain and iridescent glass mosaic tiles in a mixture of turquoise blues to tile the fish's body. The iridescent tiles will give an extra shimmer over the surface. Use the lighter blue tones in the middle and the darker tones at the edges to make the body appear more rounded. Leave the glue to dry completely.

5 Grout the fish with the sky blue-coloured grout (see pages 33–35), taking the grout over the edges to seal the gaps between the tiles and the wood. Leave to dry completely, then lightly sand around the edge to a smooth finish with fine-grade sandpaper. Glue the fish to the backboard above the plinth with strong wood glue.

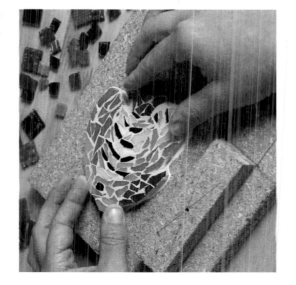

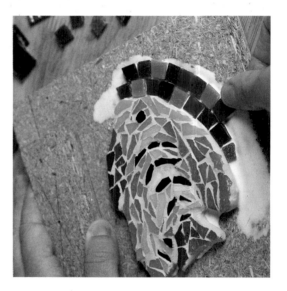

6 The backboard and plinth can now be tiled around the fish using a mixture of blue and purple glass mosaic tiles cut into quarters or small squares (see page 18). Mini mosaic tiles could be used to tile around the fish, as these are roughly the same size as regular mosaic tiles that have been cut into quarters. Tile the edges of the mosaic using eight whole tiles on each side for a chunky finish. Leave the adhesive to dry completely.

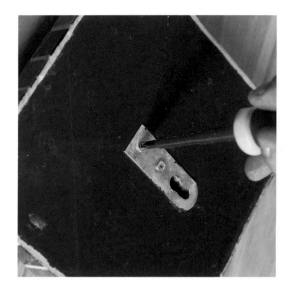

7 Grout around the fish with the indigo-coloured grout (see pages 33–35), making sure that it fills all the corners and edges and the gap between the tiles and the wood base at the back, but avoiding the pilot hole (see Tip below). Then paint the back of the wood with blue gloss paint to seal. Using the drill and a 9mm (¼in) drill bit, drill a slot in the back. Screw the hanging plate over the slot. Drill a hole in the wall and insert a round-headed screw to hang.

TIP
Using this type of fitting will ensure that the holder is secured close to the wall, reducing any potential movement to a minimum.

8 To assemble the toothbrush holder, use a screwdriver to insert a round-headed screw in the pilot hole.

TIP
To prevent the pilot hole from filling up with grout during the grouting process, insert a cotton bud into the hole.

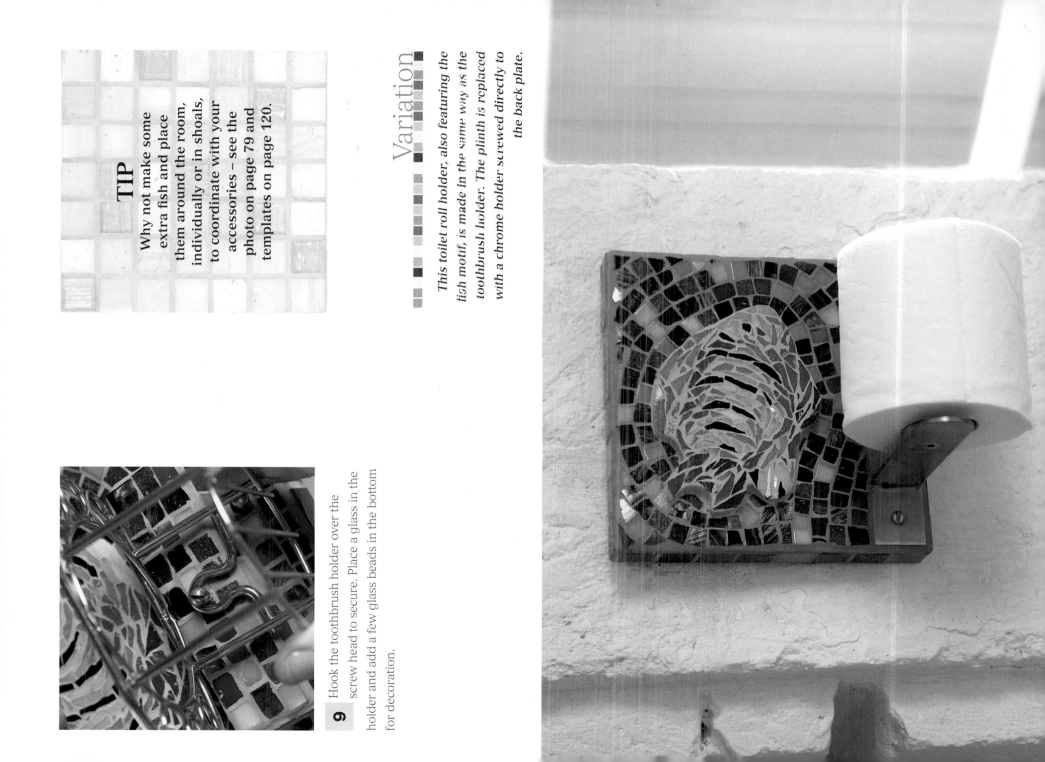

9 Hook the toothbrush holder over the screw head to secure. Place a glass in the holder and add a few glass beads in the bottom for decoration.

Variation

This toilet roll holder, also featuring the fish motif, is made in the same way as the toothbrush holder. The plinth is replaced with a chrome holder screwed directly to the back plate.

Beaded glass candle lantern

Glass-on-glass mosaics are becoming more popular, and stunning effects can be achieved when light shines through the glass, illuminating the surface. Candle lanterns provide excellent subtle lighting for adding atmosphere. Light the candles at dusk or in a darkened room to reveal the shimmering glow. The glass beads will become translucent, with the flame radiating through them. The mosaic will also have a filigree effect, with the tiles turning transparent between a delicate mesh of grout.

YOU WILL NEED vitreous glass mosaic tiles – pinks, purples, mauves, lilacs and coppers ■ glass gem beads – purple and mauve ■ purple glass candle lantern with detachable metal holder for 2 tealights ■ polyurethane glue ■ lilac-coloured powdered grout (see pages 30–32)

The mosaic is made with vitreous glass mosaic tiles using the direct method (see page 23). The lantern measures 20cm (8in) in height and 9cm (3½in) in diameter.

Beaded glass candle lantern

1 Detach the metal tealight holder from the glass lantern and set aside. Start to cut a mixture of mosaic tiles into small rectangles; to get uniform-sized pieces, firstly cut the tiles into halves (see page 18), then divide each half into three equal pieces, as shown.

2 When you have cut a good mixture of colours, begin to glue them onto the glass using polyurethane glue. This type of gel glue is thick, has no vertical slippage and dries transparent. Tile a vertical row at a time.

3 Place three glass beads at random intervals on every second row. Continue until you have covered the side of the glass lantern completely. This type of glue dries slowly and will need to be left for at least 24 hours before grouting can begin.

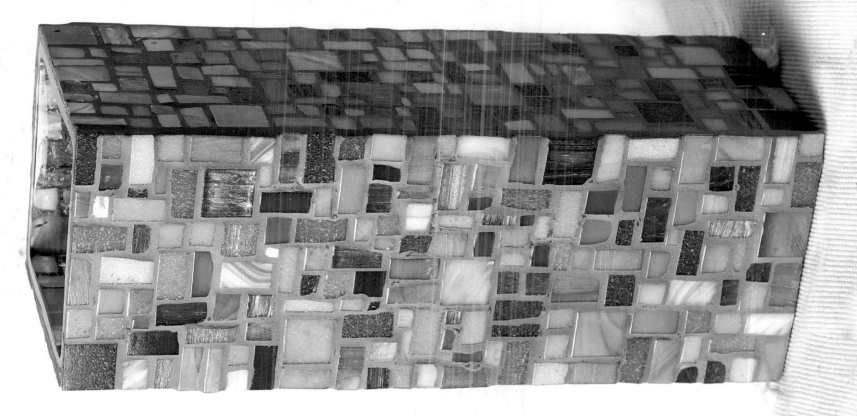

4 Grout with lilac-coloured powdered grout, ensuring that it is pressed firmly around the glass heads to embed them (see pages 33–35). Grout the rim, sealing the gap between the glass and tiles. Once the grouting is completely dry, polish the mosaic with a soft cloth, then insert the metal holder and candles.

TIP

With polyurethane glue, it is important to work cleanly, as once set, it will be impossible to remove, and any excess glue left around the tiles will not cover with grout and sit untidily on the surface. Make sure that you wipe any excess from the surface while the glue is still soft.

Variation

Influenced by 1930s abstract patterns, this Art Deco-style glass vase can also be used as a candle lantern. The tiles have been cut into varying sizes of squares and rectangles (see page 18), fitted together in a tight pattern, to emphasize the solid shape and to keep the texture even.

Arabian-inspired vase

Inspired by ancient Arabian urns, this vase features a simple pattern of bold swirls surrounded by marbleized metallic duck egg blues and greens, and looks stunning with a single-stem bloom, such as a gerbera, or a small bunch of delicate flowers like sweet peas. A strong cardboard papier mâché base is used, with a removable metal tube inserted into the top that holds the water for the flowers. Vase bases come in other shapes and sizes, like the upright one behind, whose vertical linear design in warm, rich earthy tones is African in style.

YOU WILL NEED vitreous glass mosaic tiles – iridescent pewter and marbleized duck egg blue ■ ceramic mosaic tiles – blue/green ■ paper mâché vase base with removable metal tube, 18cm (7in) in height and 66cm (26in) in circumference ■ thick marker pen ■ PVA (white) adhesive ■ yacht varnish ■ blue-coloured powdered grout (see pages 30–32) ■ sticky-backed felt or velvet

The mosaic is made with vitreous glass and ceramic mosaic tiles using the direct method (see page 23). The vase measures 18in (7in) in height and 66cm (26in) in circumference.

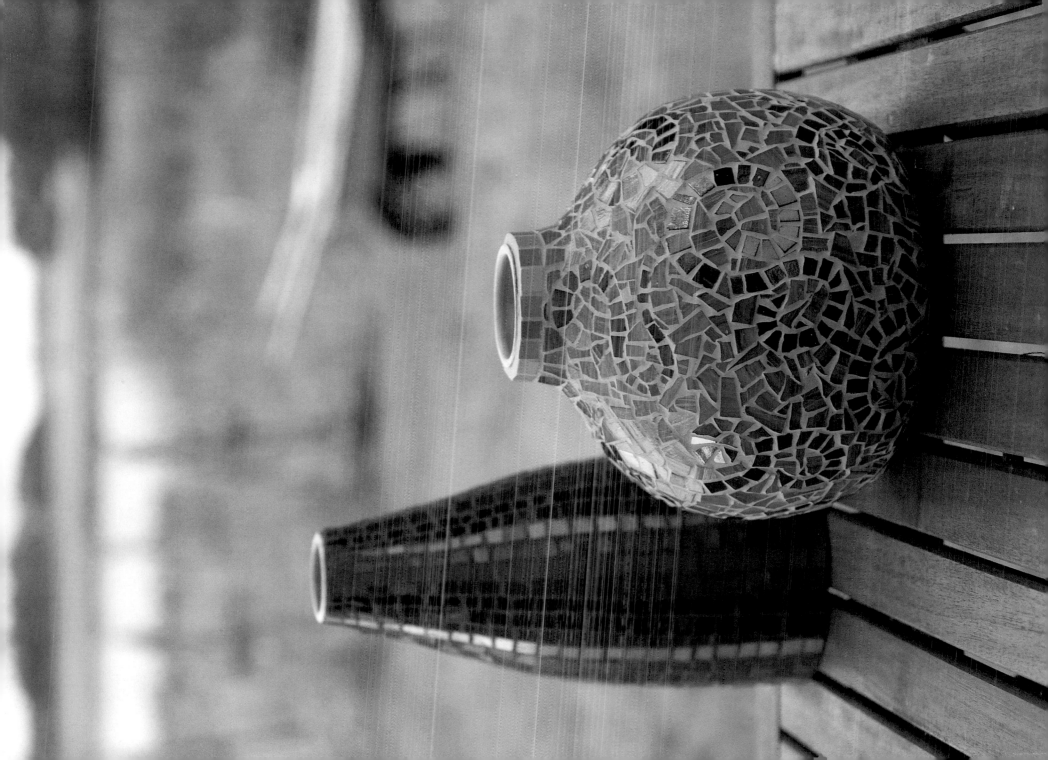

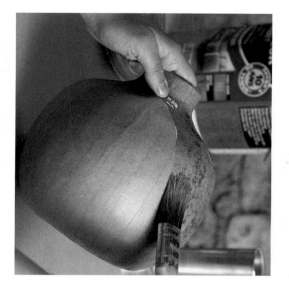

1 To make the papier mâché base strong enough to hold the mosaic, seal and weatherproof the surface; although the vase will not actually contain any water, as the removable metal tube holds the water, it must still be sealed to make sure that when the wet grout is applied, it will keep its shape and not distort. Follow the instructions for Papier Mâché Shapes, page 11, leaving to dry thoroughly between coats.

2 Referring to the template on page 120, sketch a pattern of large interconnecting swirls that flow around the vase directly onto the surface with a thick marker pen.

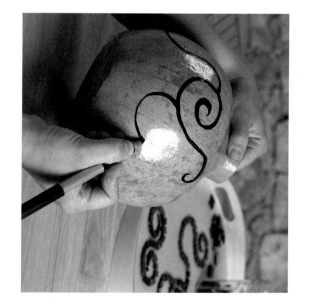

3 Cut the pewter tiles into squares. Glue around the vase with PVA (white) adhesive, spacing them evenly. To make a more flowing curve, mix square-cut with trapezoid-shaped tiles (see page 18); using the two shapes will keep the corners of the tiles parallel to each other and the arc tight. To give the lines more movement and energy, gradually increase and decrease the tile sizes. Leave each side to dry completely before rotating the vase, to avoid dislodging any recently tiled areas. If tile slippage occurs when too much glue is on the surface, wait for the glue to dry to a thick, tacky consistency and recommence tiling.

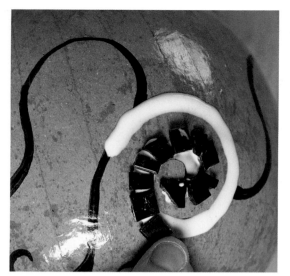

4 Cut tiles into random-shaped pieces and fill in the spaces between the swirls.

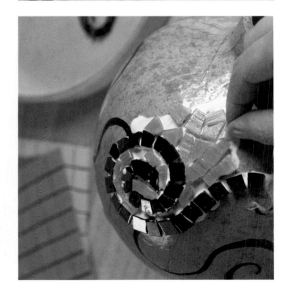

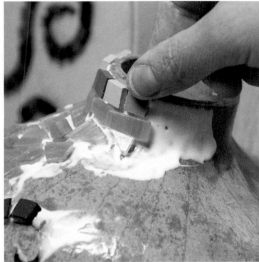

5 The mouth of the vase has a row of square-cut ceramic tiles to form a neat edge. The mosaic must follow the curve of the vase; in order not to have any protruding pieces, cut the tiles to an even size. Leave to dry completely. Stand the vase on newspaper to grout with blue-coloured powdered grout (see pages 33–35). Fit a circle of sticky-backed felt or velvet to the bottom of the vase to finish.

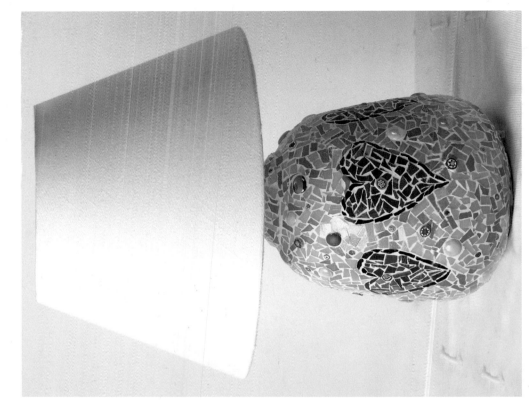

Variation

Lamp bases can be covered in a mosaic design in the same way as the vase base. In this example, with a simple heart motif, shiny and frosted glass beads together with delicate millefiori beads are interspersed between the mosaic tiles to create a vibrant, innovative design.

Art Nouveau wall clock

Soft pastel shades and elegant flowing lines are the key characteristics of this delicately styled wall clock. The design features a rosebud motif inspired by the Art Nouveau period around 1880 to 1920.

YOU WILL NEED plain ceramic mosaic tiles – pinks, greens and creams ■ black vitreous glass mosaic tiles ■ piece of 9mm (¼in) plywood, 25cm (10in) square ■ 4 pieces of 13mm (½in) square picture framing wood, 26cm (10¼in) in length ■ long shank quartz clock movement, 13mm (½in) in length ■ set of plain hands, 9.5cm/6cm (3¾in/2¼in) ■ PVA (white) adhesive ■ dark wood stain ■ strong wood glue ■ cream-coloured grout (see pages 30–32)

The mosaic is made with ceramic and vitreous glass mosaic tiles using the direct method (see page 23), and finished with a simple dark-stained frame. The clock measures 25cm (10in) square.

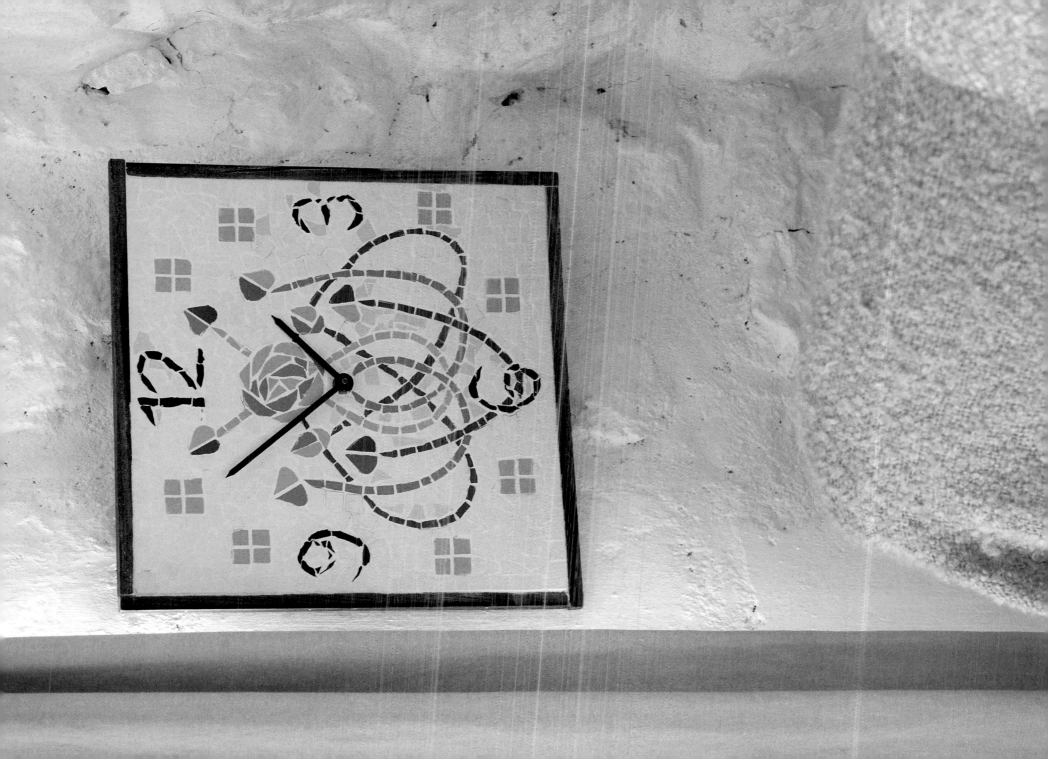

1 Locate the centre of the piece of plywood. Using a drill and a 10mm (½in) drill bit, drill a hole through the centre. Using the template on page 121, sketch or trace and transfer the design onto the plywood (see page 15). Colour in the different elements of the design with colouring pencils.

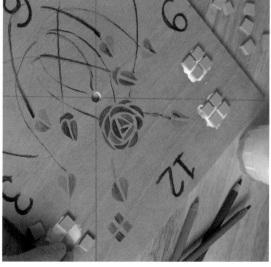

2 Start by cutting 32 pink ceramic tiles into quarters (see page 18) to form the squares that make up the markers in the spaces for the missing numbers. Glue these in place with PVA (white) adhesive.

3 Cut the black glass tiles into thin lines (see page 18) to create the numbers and glue in place. It can be quite difficult to get very thin pieces of tile to adhere effectively to the base. Try to make sure that the tile has enough depth and contact area for the glue to prevent it from toppling over.

4 To create the rosebud motif, cut pink ceramic tiles into triangular half pieces (see page 18), 'nibble' to round the edges of the two sides that meet together in a point (see page 19) and then position to form interlocking petal shapes. Cut the leaves and stems carefully from green tiles, keeping the pieces evenly spaced and sized. Try to make sure that the design stays evenly balanced.

5 Tile the background with randomly nipped cream tiles. You will need some small pieces to tile neatly between the stems, roses and numbers. Then leave the adhesive to dry completely.

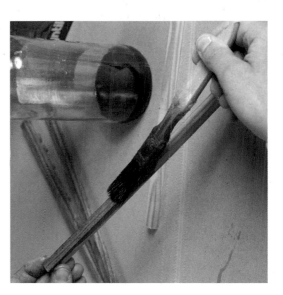

6 Using a paintbrush, apply a dark wood stain to the four lengths of framing wood. Once the stain has dried completely, attach the frame to the edges of the clock face with strong wood glue.

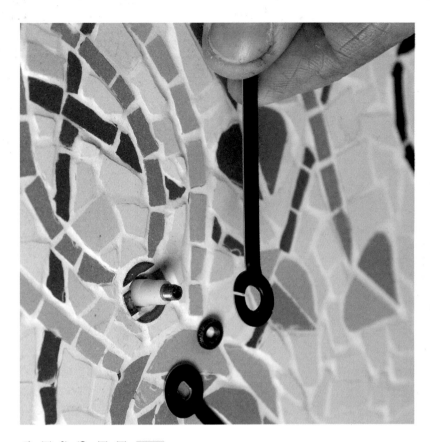

7 Grout the clock face with cream-coloured grout (see pages 33–35). Remember to keep the drilled central hole free of grout (see bottom Tip, page 82) and to make sure that the grout fills right up to the frame edges. To assemble the clock movement, pass the battery box through the drilled hole from the back of the mosaic and fix the hands to the front.

TIP

To make sure that the clock hands move freely, the depth of the quartz movement shank must be deeper than the wood and tiles combined so that the hands are raised slightly from the mosaic.

Variation

To make this matching rosebud mirror (see page 121 for the template), you can use the same size of plywood and frame as the clock, but replace the drilled hole in the centre with a routed cutout 10cm (4in) square for the mirror. For this design, a mixture of marbleized glass mosaic tiles has been used with the plain ceramic tiles to give more depth and to add a delicate sparkle to the frame.

Apply sticky-backed plastic to the mirror glass (see Step 1, page 40) to protect its surface from damage while tiling.

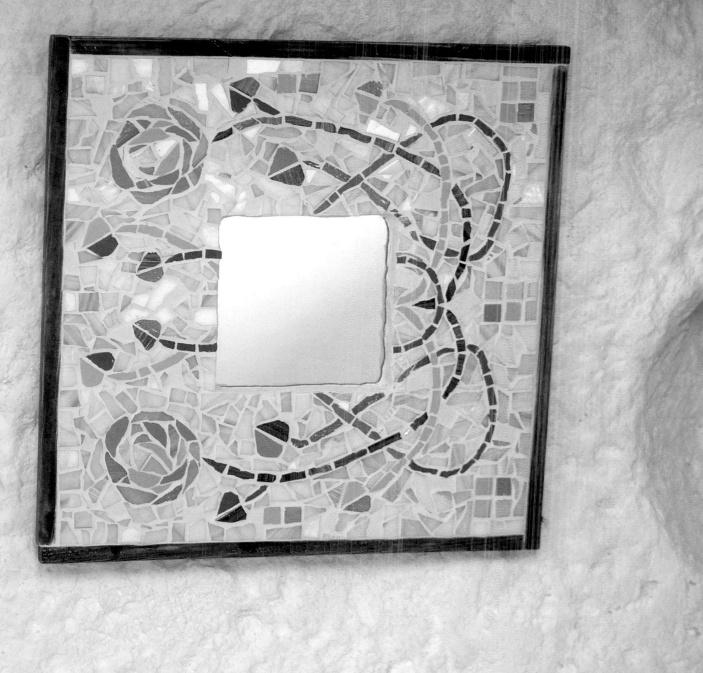

Abstract
birdbath

Attract birds into the garden with this eye-catching birdbath. It combines a Victorian-inspired colour scheme of salmon pinks and cobalt blues with an abstract design that mixes glass and millefiori beads with ceramic and glass tiles. The tiles will shimmer and glisten when the water and sunlight play on the surface.

YOU WILL NEED vitreous glass mosaic tiles – blues, pinks and coppers ■ ceramic mosaic tiles – blues and pinks ■ glass gem beads – blues and pinks ■ blue millefiori beads ■ terracotta plant pot saucer, 35cm (13¾in) in diameter ■ silicone glue or polyurethane glue ■ dark grey-coloured powdered grout (see pages 30–32)

Terracotta plant pot saucers make excellent birdbaths and are easily available from all garden centres in a variety of sizes. The mosaic is made using the direct method (see page 23), and the birdbath measures 35cm (13¾in) in diameter.

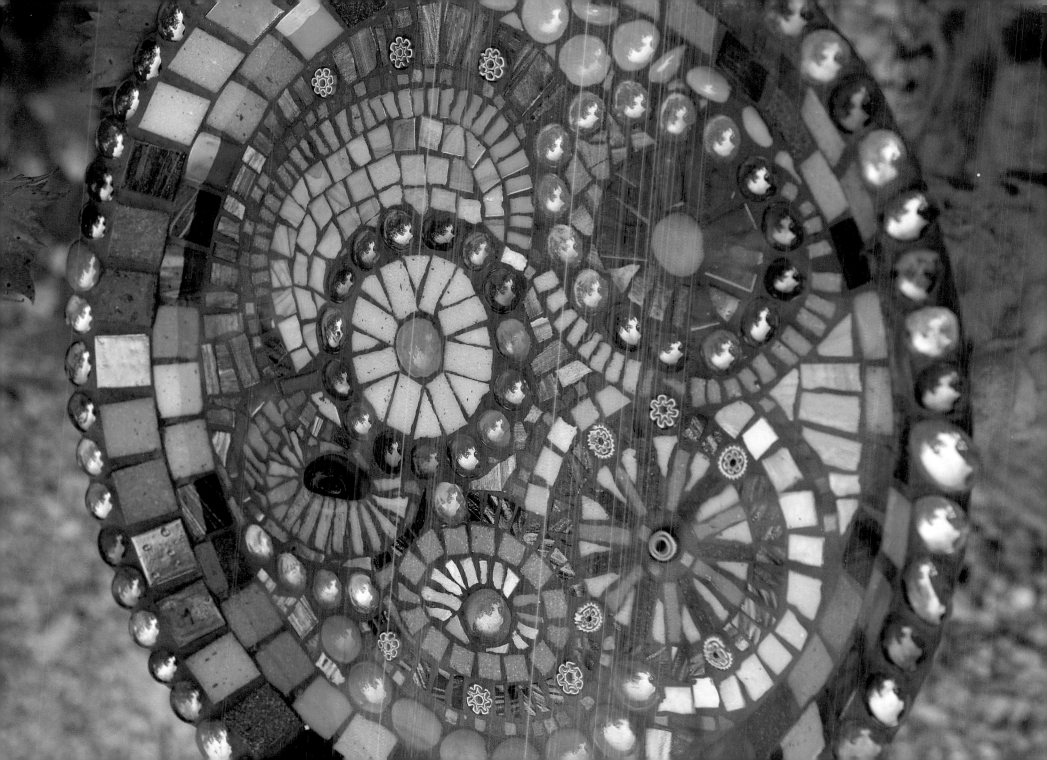

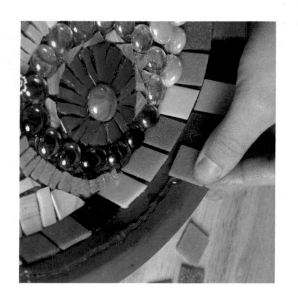

2 Using silicone or polyurethane glue, tile the base of the saucer with an assortment of materials. Start by creating the circles and then spread the patterns outwards until they meet and fill the surface. Abstract patterns tend to evolve as the mosaic develops; it should be free flowing and a mixture of uniformly cut pieces mingled with irregular areas. Try shading the rows, from dark to light, to give added depth.

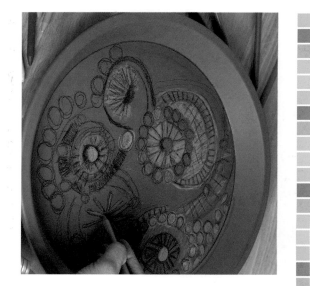

1 Using the template on page 122, sketch or trace and transfer the abstract pattern onto the saucer (see page 15). Roughly sketch in the different-coloured areas of the design with wax crayons.

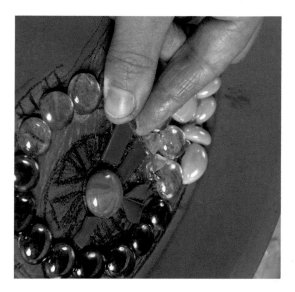

3 Tile the edge of the saucer with two rows of tiles. Tile the row closest to the base first and then place the second row on top. Don't line the tiles up across the rows; instead, create a brick wall-style effect for a more professional look. Keep the spacing even all the way around so that there are no cut tiles to draw the eye.

4 Add a row of glass gem beads to the rim of the saucer, again spacing them evenly. Leave the glue to dry completely. Grout the mosaic with dark grey-coloured powdered grout (see pages 33–35).

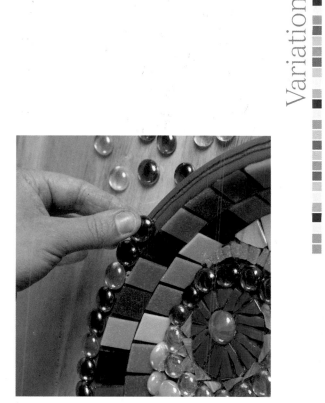

TIP

Using dark grey-coloured grout serves to intensify the colours of the mosaic and frame the tiles (see pages 28–29).

Variation

Try decorating some bird boxes to match. These round wooden bird boxes were tiled using the direct method (see page 23). Garden centres stock many different ready-made bird houses in a range of shapes and sizes, but make sure that the base is wood and remember to seal before tiling (see page 9).

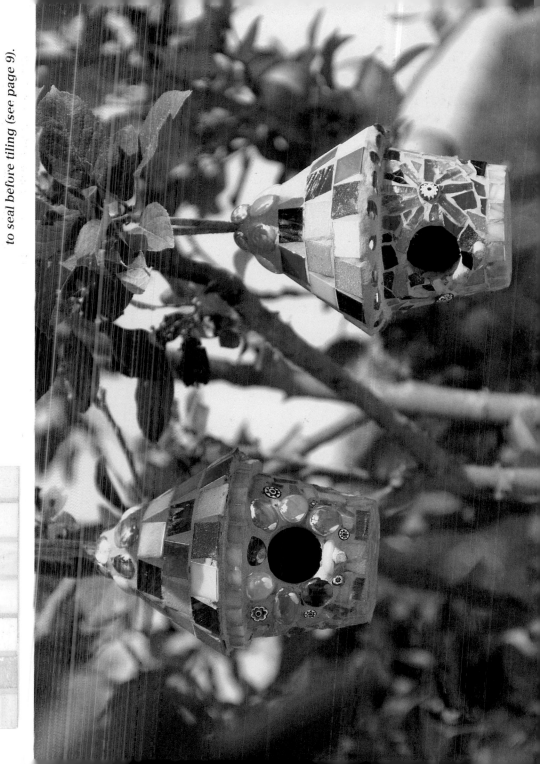

Lizard garden plant markers

These lizards are mounted onto solid wood stakes and are designed to sit in low border planting areas of your garden, nestling between the leaves. A wooden clothes peg glued to the front of each stake can hold a seed packet to mark rows of vegetables or plant information relating to adjacent shrubs.

YOU WILL NEED vitreous glass mosaic tiles – black, forest, deep and olive greens and coppers ■ mixed green glass beads ■ piece of 6mm (¼in) marine plywood, 60 x 50cm (24 x 20in), or two pre-cut MDF lizard shapes (see page 9) ■ 2 wooden garden stakes with two flat sides, 70cm (27½in) in length and 2.5cm (1in) in diameter ■ 2 wooden clothes pegs ■ PVA (white) adhesive ■ yacht varnish ■ polyurethane glue or silicone glue ■ green-coloured powdered grout (see pages 30–32) ■ weatherproof paint ■ dark wood stain or exterior varnish ■ 2 metal bracket fixings ■ strong wood glue

Many craft stores stock pre-cut MDF lizard shapes, which will save on complicated wood cutting. The mosaics are made with vitreous glass tiles using the direct method (see page 23). The small lizard measures 37 x 15cm (14½ x 6in) and the large 36 x 30.5cm (14¼ x 12in).

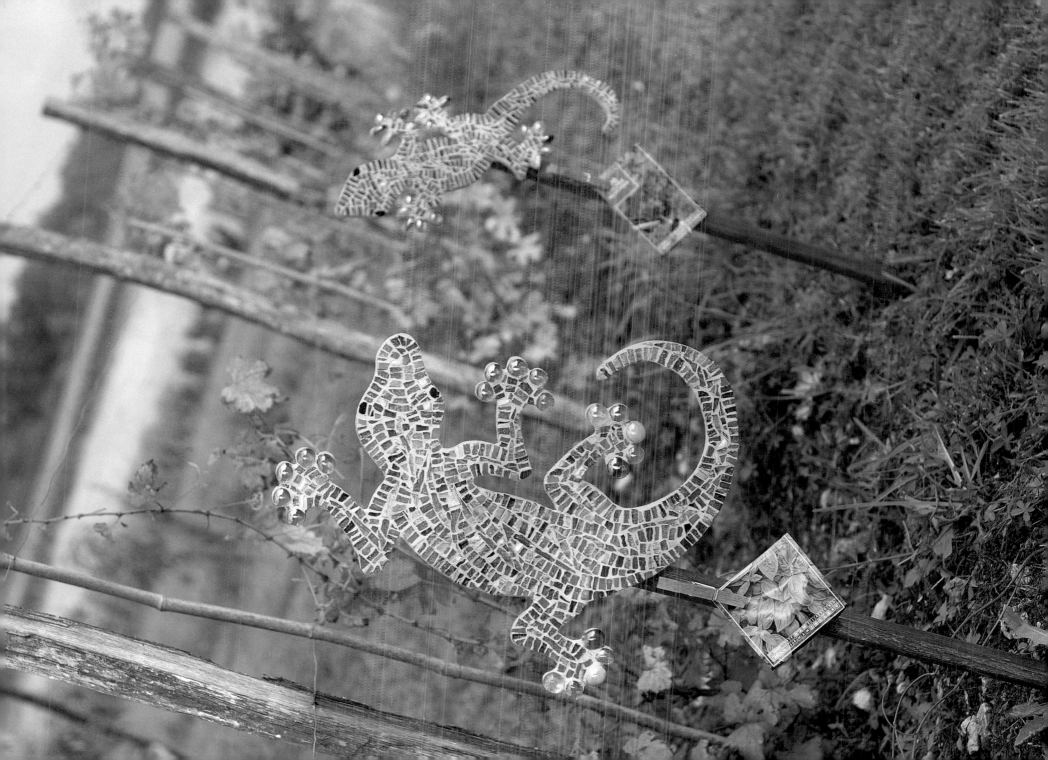

1 If not using pre-cut MDF lizard shapes, using the templates on page 122–123, sketch or trace and transfer the lizards onto the piece of marine plywood and cut out with a scroll saw. Seal and weatherproof the surface of the MDF or plywood – follow the instructions for Pre-cut MDF Basc Shapes, page 9. Sketch the spine line and features onto the shapes, then start by shaping two pieces of black tile (see page 19) for the eyes and glue in place with the polyurethane or silicone glue. Tile the flashes of copper down the spine and legs before filling in the rest of the body with the green tiles.

2 To give the impression of scaly skin, the tiles have been cut into thin, rectangular strips (see page 18) and glued in loose rows, defining the lizards' edges and flowing down the body. Glue five beads onto the feet, cutting some in half to elongate the claws. Glass beads can be cut with standard mosaic nippers in the same way as flat glass mosaic tiles, and will cut cleanly if held tightly, but are much thicker, so will require greater force to fracture. Leave the glue to dry completely.

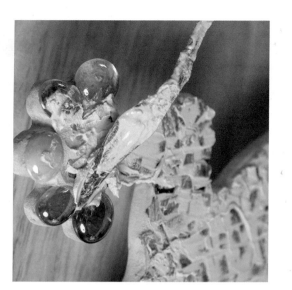

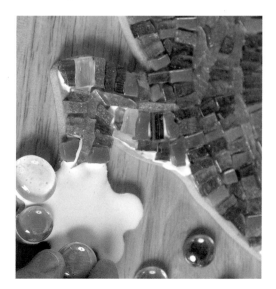

3 Grout the lizards with green-coloured powdered grout (see pages 33–35). Grout the edges carefully to seal the shape and fill the gap between the tiles and the base. Use the tip of a pointed palette knife to press the grout deeply into the gaps and carefully scoop the grout around the raised beads to embed them. Once the grout is completely dry, lightly sand around the edge with fine-grade sandpaper to a smooth finish. Paint the back of each lizard with weatherproof paint for extra protection.

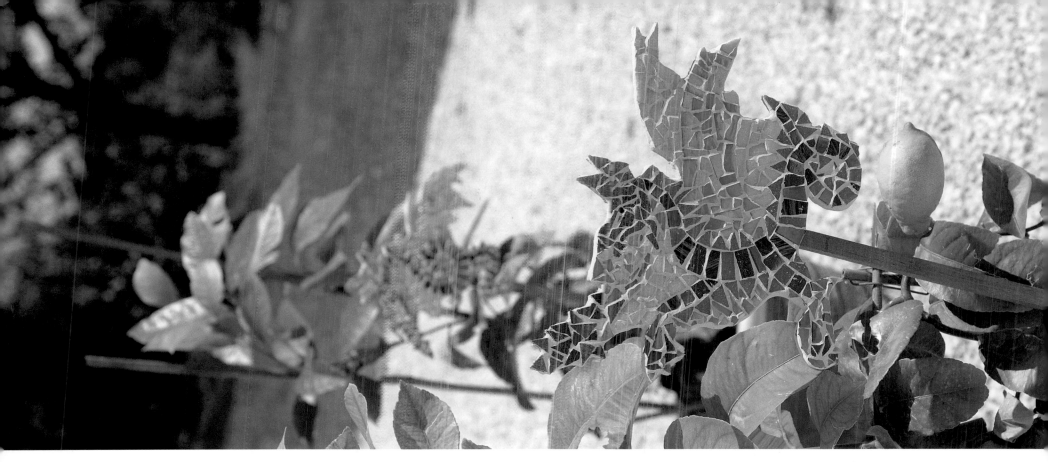

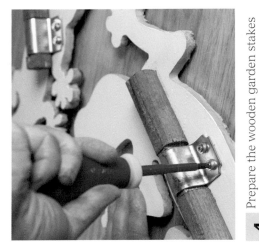

4 Prepare the wooden garden stakes by painting with wood stain or yacht or exterior varnish. Leave to dry, then fit a metal bracket around each stake ready for securing to the lizard. Stain or varnish the wooden clothes pegs too. Screw each metal bracket to the backs of the lizards.

5 Using strong wood glue, glue a peg to the front of each stake just under the lizards to finish.

Variation

Created in the same way, these dragons make exotic sparkling sculptures for the garden (see pages 121–122 for the templates). They will look as fresh and new as when they were first made through all the seasons, since they will not fade in sunlight nor degrade in frost.

Poppy candle shelf and saucer

When a lighted candle is placed on this striking candle shelf in a coordinating saucer, the mirror tiles reflect the candlelight back from the mosaic and the glass tiles shimmer as the candle flickers – perfect for bringing atmosphere to a courtyard garden or patio dining area.

YOU WILL NEED vitreous glass mosaic tiles – black, reds and metallic lime and olive greens ■ mini mirror tiles (usually supplied on a fabric sheet), 15mm (½in) square ■ piece of 19mm (¾in) marine plywood or external waterproof chipboard, 50cm (20in) square ■ terracotta plant pot saucer, 7cm (2¾in) in diameter ■ polyurethane glue or silicone glue ■ lime green-coloured powdered grout (see pages 30–32) ■ weatherproof paint ■ sticky-backed plastic ■ strong nail

The candle shelf and saucer mosaics are made with vitreous glass mosaic tiles, with the addition of mini mirror tiles for the candle shelf, both using the direct method (see page 23). The candle shelf measures 20 x 40 x 20in (8 x 16 x 8in) at its longest edges, while the saucer is 7cm (2¾in) in diameter.

1 Mark out a rectangle on the piece of plywood or chipboard for the back plate measuring 40 x 20cm (16 x 8in) and draw a vertical line down the centre from top to bottom. To create the point, measure 26cm (10in) up from the bottom on both long edges and draw a horizontal line across the rectangle. Then draw a diagonal line down from the top of the vertical line to meet each of the top corners of the horizontal line. Cut out the pointed tip with a jigsaw. Measure 5cm (2in) down the central vertical line from the tip. Using a drill and 9mm (¼in) drill bit, drill a pilot hole for hanging.

2 Cut a triangular piece of plywood or chipboard for the shelf measuring 20cm (8in) on all sides. Position the shelf in front of the back plate, and using a 3.5mm (⅛in) drill bit, secure in place with three woodscrews.

3 Seal the wood by brushing all over with a solution of diluted PVA (white) adhesive (one part PVA/white adhesive to five parts water) and leave to dry.

4 Using the template on page 123, sketch or trace and transfer some poppies, poppy buds and stems onto the back plate and shelf, then colour in with wax crayons or colouring pencils (see page 15).

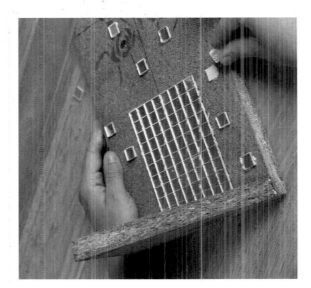

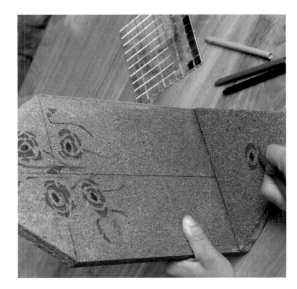

5 Cut two sheets of mini mirror tiles to measure 12 x 10cm (5 x 4in). Cover the front of one sheet with a piece of sticky-backed plastic, to avoid scratching the surface while working on the mosaic. Glue the uncovered sheet of mirror tiles into position on the back plate and then glue the second sheet with the protective plastic directly on top (it should fit exactly), to raise them to the same height as the surrounding glass and ceramic tiles. Add a few extra single mirror pieces to the back plate for added sparkle, again doubling to the correct height and protecting with the plastic.

6 Using polyurethane or silicone glue, tile the poppies (see Steps 7–8, page 110), buds and stems. Tile around the poppies and mirror tiles with green tiles cut into quarters (see page 18) or mini mosaic tiles in neat lines. Tile the edges with whole tiles. Leave the adhesive to dry. Remove the plastic from the mirror tiles. Grout with lime green-coloured powdered grout and finish in the usual way (see pages 33–35) – place a cotton bud in the drilled hole to prevent it filling up with grout. Paint the back and bottom of the shelf with weatherproof paint for extra protection. Fix to the wall using a strong nail through the hole.

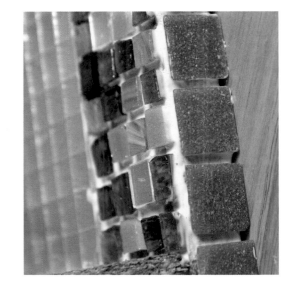

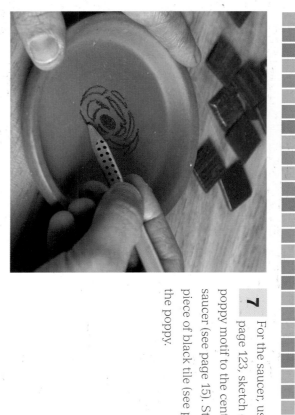

7 For the saucer, using the template on page 123, sketch or trace and transfer the poppy motif to the centre of the terracotta saucer (see page 15). Start by cutting an oval piece of black tile (see page 19) for the centre of the poppy.

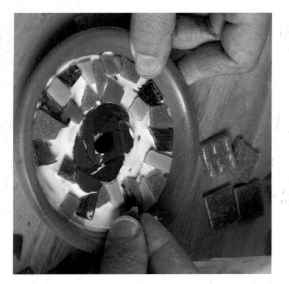

8 To make the poppy's outer red petals, cut the tiles firstly into two large triangular pieces across the diagonal (see page 18), and then 'nibble' to round slightly the two sides that meet together in a point (see page 19). Position to form interlocking petal shapes, as shown. As you add petals, the poppy will develop into an elongated oval shape. Glue these pieces firmly in place.

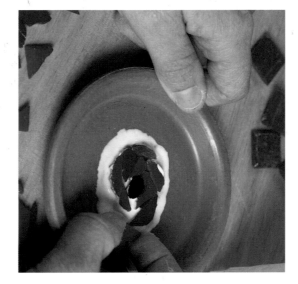

9 Cut the green tiles into random pieces to fill the background. Tile the inner base of the saucer, leaving the edge as bare terracotta, to help frame the miniature mosaic and enhance the finish. Leave the glue to dry. Grout the saucer with a lime green-coloured powdered grout (see pages 33–35). Keep the saucer edge clean and free of grout for a more professional finish.